Complete
Shibari

Volume 2

Sky

Complete Shibari Volume 2: Sky
ISBN: 978-0-9736688-2-7
Copyright © 2010 by Douglas Kent
www.CompleteShibari.com

Published by:
Mental Gears Publishing
www.MentalGears.com
Ottawa, Canada

All content including all text, drawings, art work, rigging, photography, and layout by Douglas Kent. Cover image by Mark Chong. Cover design by Douglas Kent.

All models depicted herein are over the age of 18; releases are on file.

Booksellers: For best results, display in the Sexuality section.

Printed in Canada
1.00 10 9 8 7 6 5 4 3 2 1
Series ISBNs
Volume 1: ISBN: 978-0-9736688-1-0
Volume 2: ISBN: 978-0-9736688-2-7

Thank you

I was also overwhelmed by the support and help given to me by my friends. I couldn't possibly list all the ways people helped, but you all have my deep gratitude:

Alia Mahabir, Cathrine P., Hank M. Walker, Tammie Tam, Alannah Borden, Barry Beldam, Graydancer, Christina K., Rigger MorTis, Dov, Jeff Vrstal, Lee Harrington ("Shibari You Can Use"), Gregory McCormick, Melang Le, Robert MacMillan, Chris Paci, Yugo Kotake, and all the instructors at Shibaricon

Image touchup crew

A small group of incredibly dedicated friends shared my vision of a bright, clean, friendly layout and, through hundreds of hours of effort, made it *exist*. I can't possibly thank you enough:

Kristina Hall, Serenity9, lotuslily, Véronique Ayotte

Models

I was fortunate to find beautiful, consistently cheerful girls who trusted me to keep them safe during shoots that were long and often both daring and uncomfortable. Thank you for your contribution, enthusiasm, and trust:

Sabrina K. Lee, Siren Thorn, lexi, lotuslily, Nyssa Nevers, Véronique Ayotte, Chase Marlène, Annika Vander Kooy, Cathrine P., Susannah

Warning and disclaimer

The author and publisher assume no responsibility whatsoever for any loss, injury, or damage resulting from the ideas in this publication, caused by inaccuracies, omissions or inconsistencies in this publication, or for the reader's failure to follow instructions. Further, the author and the publisher assume no responsibility whatsoever for any injury or damages resulting from the use of this publication.

The use of bondage, BDSM and sex toys may be dangerous if proper caution and prudence are not exercised. However, injuries can and do occur, even if all precautions are taken.

By acting on the information contained in this book, you agree to accept the information as is.

The use of drugs and alcohol can seriously impair judgment and/or increase risk.

About the ropework

The ties and suspensions in the *Complete Shibari* series are real. Image editing consisted of touchups and background removal only; no rope or prop was added or removed.

All ropework techniques required to reproduce the photos are contained within the *Complete Shibari* series.

The ties featured in the procedures are generally traditional in nature; the artistic ties are generally non-traditional.

Artistic photos were limited to full-view images that clearly showed all ropework. Photos were taken in a small living room with a 2.4 m ceiling

Note that the models depicted are often exceptionally light, fit, and/or flexible. Many of the artistic photos were deliberately physically challenging to produce a more dramatic visual effect. Some ties were maintained only for the few minutes or seconds required to obtain the shot.

About the author

Douglas Kent can't keep from writing expansive books about esoteric topics.

In loving memory of my grandfather.

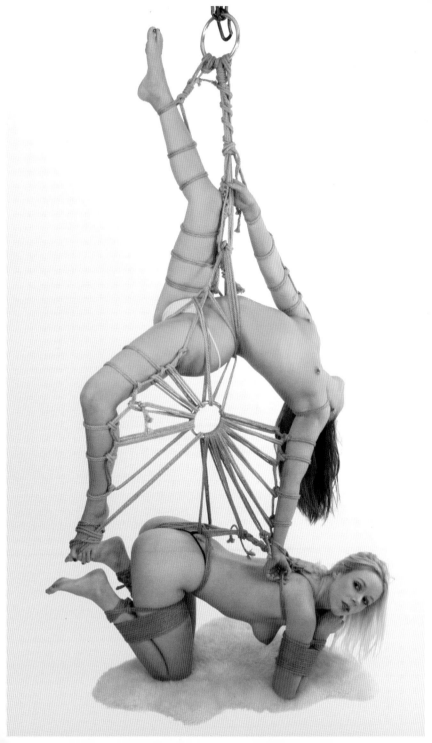

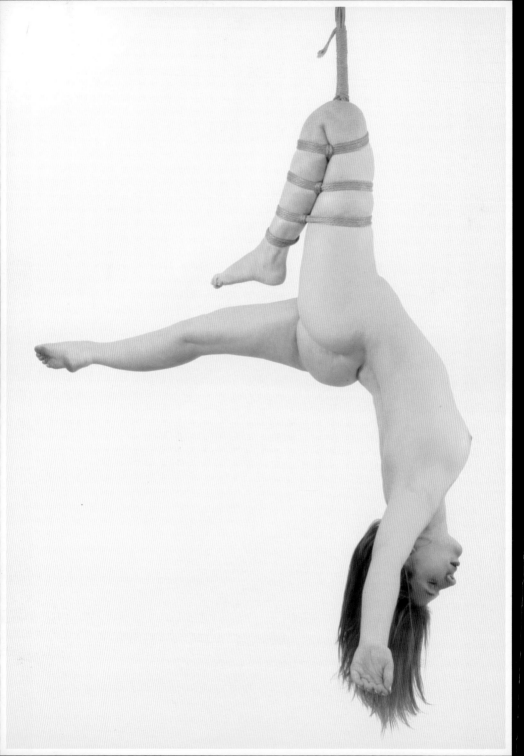

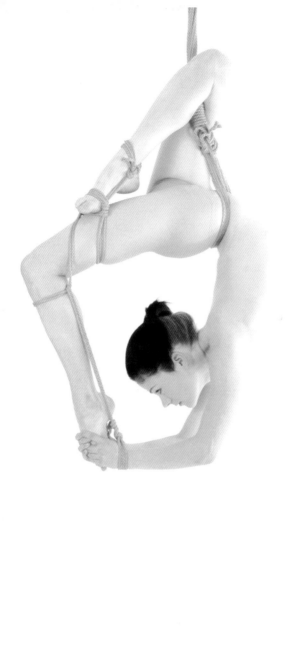

Visual index of ties

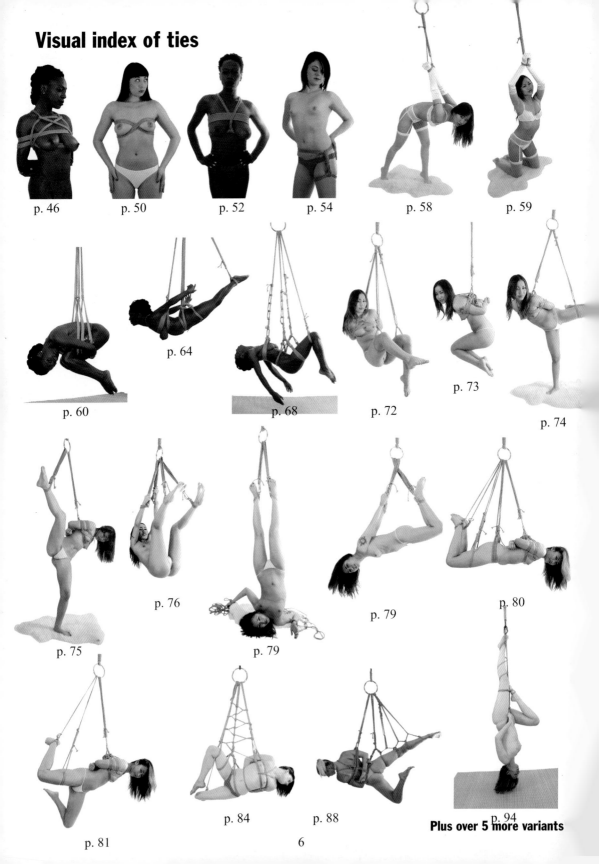

p. 46

p. 50

p. 52

p. 54

p. 58

p. 59

p. 60

p. 64

p. 68

p. 72

p. 73

p. 74

p. 75

p. 76

p. 79

p. 79

p. 80

p. 81

p. 84

p. 88

p. 94

Plus over 5 more variants

Index

Introduction

Building blocks

Forms

About Complete Shibari: Sky

The teaching of rope suspension is a controversial subject. There are those that feel that rope suspension is dangerous and should only be taught in person.

Compared to reading, watching television, or playing cards, rope suspension *is* dangerous. However, when more fairly compared with sports like downhill skiing, wall climbing, cycling, or even jogging, its dangers rank somewhere in the middle of the pack.

In truth, rope suspension is as dangerous as you make it. Almost any sport is much more dangerous if you approach it with an unfit body, a cavalier attitude, or foolish bravado. In the extreme, any of those sports can kill you. However, with a thoughtful approach, you can virtually eliminate the major dangers and mitigate the smaller ones.

Sure, you can expect regular dents and dings along the way, but they're a normal part of being a healthy, active person.

The assertion that rope suspension should only be taught in person is at odds with the problem every teacher (and every rope teacher) faces: people forget. The problem of forgetfulness is exacerbated by the non-academic nature of rope courses – no one takes notes. In fact, in dozens of courses with hundreds of students, I was consistently the only person taking full notes. And I only did so because, hey, I'm writing a book and stuff.

Research suggests that to best retain information, you must recall it immediately, a day later, and a week later. However, with rope suspension, that involves practice. And when practicing rope suspension, it's not enough to recall the general idea – the details matter. Unfortunately, courses rarely have daily and weekly follow-ups, and most people couldn't afford them, even if they were available. So what happens? The great bulk of the teaching is lost.

In Japan, many disciplines are passed from the master to the student through apprenticing rather than courses. The master doesn't explicitly teach, so the student is expected to "steal" the knowledge. In exchange, the student usually performs the master's menial chores… for years. While very traditional, I can hardly imagine a more frustrating way to learn. Not only is the process incredibly slow and inefficient, the reasoning behind any procedure is left to the student's best guess.

Complete Shibari: Sky is my best guess – a snapshot of an ever-changing oral tradition that will continue to grow and develop. Though I consider my techniques to be very respectful of tradition, like anything "stolen" by an apprentice, they're colored by my own personality.

Complete Shibari: Sky features:

- Separate explanations of basic "building block" procedures that extend the knowledge you gained in *Complete Shibari: Land*. (However there's *no* repetition, so you *must* read *Land* first!)
- A thorough safety section that builds on the large safety section in *Complete Shibari: Land*.
- The first in-depth "Suspension physics" section in any shibari how-to book in any language (to my knowledge).
- A "Suspension skills" section that explains the actions and reasoning behind the actions.
- The same iconized procedures as in *Complete Shibari: Land*, slightly augmented to include icons for new suspension-only procedures.
- A large number of suspensions packed into a small, affordable format.
- As many images as possible.
- As few words as possible.
- Adaptations that account for the taller, heavier bodies typically found outside of Japan.
- Inspirational artistic photos that are uncropped and clear enough to reveal how they were created.
- Introductory suspensions that let you practice your technique in a controlled manner.
- Advanced suspensions that can challenge even nimble rope bottoms.

It's my sincere belief that *Complete Shibari: Sky* contains the foundation knowledge you require to learn become a shibari expert… in your own home, and on your own time. If you're new to rope suspension, you're about to join the ranks of Arisue Go, Randa Mai, and dozens of other highly-regarded riggers – all of whom learned shibari through books, pictures, and careful practice. It's how I learned, too.

Though I wrote this book for beginners, if you're an experienced rigger, perhaps you'll learn a few new techniques from this book, too. And if you're an instructor and firm believer of in-person learning, perhaps the *Complete Shibari* series can earn a place as your course notes… so you can spend more time refining your students' techniques and less time teaching them from scratch. In my opinion, that's a far better use of an expert's time.

Used irresponsibly, the information in this book can help you or your partner acquire a serious injury. Used with care, thoughtfulness, and respect, *Complete Shibari: Sky* can be the foundation for you to feel the exhilaration, pride and intimacy of becoming an expert rigger.

To my knowledge, *Complete Shibari: Sky* is the most exhaustive, accessible English-language suspension book in existence. It's the culmination of four years of research, planning, and writing. *Complete Shibari: Sky* represents the expansive textbook for the rope-suspension course I never took, packed into a small, compact form that you can easily carry in your rope kit and refer to in an instant.

Complete Shibari: Sky has been a labor of love. It's the best way I can share my passion for rope suspension… because it's exactly the book I wish I had when I was first learning.

Thank you very much for buying *Complete Shibari: Sky*. I hope you enjoy it.

Sincerely,
Douglas Kent

Don't be Some People!

Not all will be satisfied with the warnings and disclaimers in the *Complete Shibari* series.

"Some People will see the circus performer doing the one-leg suspension on the splash page and think they can do it."

"Some People will see the list of unacceptable rope types and think that they can use steel wire instead of rope."

"Some People will see the limb lifts and think the neck is a limb."

"Some People will...", well, you get the idea.

Though well-intentioned, this type of statement has two core presumptions.

The first presumption is that people exist that are much more stupid than the person making the statement. Hey, statistically, they must exist, but probably not in nearly the numbers that the speaker presumes – people tend to believe that they and their friends are of above average intelligence.

I personally prefer to assign a little more intelligence and sense of self-preservation than is usually attributed to Some People.

The second presumption is that anything I could possibly write would save these stupid people from doing stupid things.

Ultimately, if Some People have survived this long doing stupid things, they'll probably survive this book.

So worry about Some People if you like; just don't *be* Some People.

Perfect!

A few months ago, I attended a rope social where the guest instructor demonstrated a simple one-rope tie from a well-known bondage book. Before starting, she highlighted a photograph, saying, "I wanted to point out the wrinkle in the ropework in this photograph. I can't believe this made it into the book – if I were the publisher, I'd make them *do it over!*"

A friend, knowing of my project, turned in her seat to gauge my reaction. "I'm guessing you don't agree."

When I was researching this series, I studied many Japanese texts in great detail. A great many photos had folds, twists, gaps, and other technical "errors" in the ropework. For many riggers, errors are part of their "messy" style.

As ropework becomes more complex, the likelihood of "perfect" ropework declines further.

Although I started with a specific vision of an icon-based instruction manual, the actual meaning of some of the icons evolved. In some cases, icons became redundant; in others, an icon's meaning was split, refined, or refocused. Throughout the process, *Complete Shibari* grew and evolved, as did my rigging style. Some epiphanies meant throwing out an entire day's worth of photos. A painful number of days, actually.

Before each shoot, I reminded myself to tie for clear photographic instructions rather than vanity. I reminded myself often, as I left yet another visibly dangling rope end and larger-than-necessary bight. I varied my style to acknowledge the many *possible* styles.

"Isn't that wrinkle because the rope's going over the top of the boot?"

My skills have grown over the past year and some photos may reflect a slightly older style, slightly different technique, or slightly different focus for the book.

"Perfect", announced the instructor, proudly displaying her workmanship. "And better than the photo in the book!"

I cringe a little when I look at some details of my older rigging, but I try to remember that it's part of my growth. I'm still a student and I hope to continue growing and improving over my current style.

We're not perfect, rope isn't perfect, but that doesn't stop us from trying to achieve perfection as we individually perceive it. Even if "perfect" includes wrinkles.

Safety

Graduating from floorwork bondage to rope suspensions introduces new safety considerations. This section is an extension of "Safety" in *Complete Shibari: Land*.

Bravado

Risk	★★★★★
Consequence	★★★

If you're new to shibari, there's a temptation to jump right into rope suspensions. Resist that urge. Even if you've been doing suspensions for a while, beware of attempting suspensions beyond your ability or that of your bottom.

Reducing risk

- Work within your abilities.
- Learn and prepare before trying new suspensions.

Reducing consequence

- Have a helper nearby.

Nerve damage

Risk	★★★★
Consequence	★★★★

Traditional suspensions tend to put significant pressure across the upper arm. Avoiding nerve injury is difficult because the vulnerable area is difficult to locate by sight or touch, varies by individual and body position, and is prone to asymptomatic injury.

Vulnerable nerve areas include:

- The median nerve at the carpal tunnel (symptom: sensory loss of the thumb/index/middle finger, thumb weakness).
- The ulnar nerve at the inside of the elbow (symptom: hand weakness, poor pinky finger control)
- The radial nerve at the approximate intersection of the deltoid, biceps, and triceps (symptom: "wrist drop")

The human body isn't as delicate as we tend to believe, so moderate pressure on these areas won't necessarily cause a problem. However, because nerves run throughout the length of the arm, problems may develop even without pressure in these areas. Further, repeated successful suspensions may gradually irritate nerves to the point of causing problems.

Since nerve damage prevention is imprecise, it's difficult to be proactive rather than reactive. However, at the first sign of trouble, react quickly.

Nerve damage and location is a complex subject that could easily fill dozens of pages – for detailed information, consult *The Anatomy Coloring Book* or a similar medical text.

Reducing risk

- Vary suspension positions to avoid focusing too much wear on one area.
- Ensure rope is laid flat and evenly.
- Pay strict attention to rope angle, particularly on ropes covering the upper arm. See "Understanding Suspension Physics" on page 20.

Reducing consequence

- End suspensions at the first sign of tingling or numbness, especially if the tingling affects only one or a few fingers.
- Don't "shake out" the tingling – doing so could irritate the area further.
- If you can identify the location of the nerve injury, ice the area.

Falling (Anchor point failure)

Risk	★★★
Consequence	★★★

If you installed your own anchor point (see page 14), you should have an idea of how secure it should be.

However, you may have to depend on anchor points installed by others. In finished ceilings, you may not be able to see how the point was installed.

Unfortunately, the design of many points is such that they are 100% secure a fraction of a second before they fail completely (such as a nut spinning off the last thread of a bolt).

The Better Built Bondage Book describes how to install anchor points, including how to improve the reliability of traditionally riskier installations such as screw eyes.

Reducing risk

- Inspect and test your anchor points.
- Avoid anchor points you can't inspect.
- Beware of anchor points of indeterminate strength (screw eyes in wood, anchors into concrete).
- Beware of anchor points that can unscrew during use.

Reducing consequence

- Keep suspensions close to the ground.
- Work over a mattress or a padded mat. (This may increase the risk of tripping.)
- Avoid inverted suspensions and positions likely to cause spinal injury during a fall.

Falling (Ropework)

Risk	★★★
Consequence	★★★

Once in suspended bondage, your bottom is relatively safe from falling. However, the risk is relatively high while transitioning from one

position to another (especially starting off and finishing).

Keep the consequences in context - even bound, falls are likely to be extremely unpleasant, but not permanently injurious. Bodies are more durable than we give them credit for.

Reducing risk

- Be careful when tying your bottom's ankles while she's standing.
- Avoid suspensions that depend on your strength or skill to keep her from falling (including lowering her to the ground after).
- Use pullout-style suspensions instead of lift-style suspensions. See "Suspension skills" on page 26.
- Keep suspension ropes taut for partial suspensions and other ties that depend on the bottom maintaining their balance.

Reducing consequence

- See "Falling (Anchor point failure)" on page 10.

Sawing through the bight

Risk ★★★
Consequence ★★★

The bight on a limb suspension is very delicate. If you pull on the rope to lift your bottom's limb using Limb Lift D (page 38), you can literally saw through the bight (cut the rope in two). Since the bight has no backup rope, the limb will certainly drop.

Sawing through the bight is the predictable result of improper limb lift techniques and no rope can bear this type of damage indefinitely. Thus, sawing through the bight is closer to human error than (unexpected) rope breakage.

Reducing risk

- Don't lift by pulling on the rope. Instead, lift the limb with one hand, and take up rope slack with the other.

This style of lift can damage the bight.

- The fold at the middle of the rope receives the most wear. Occasionally shorten one end by 150 mm to move the wear-gathering fold to a new place.

Reducing consequence

- Keep your hand beneath your bottom's limb during the lift.
- Don't use a Limb Lift D on a core body part.

Orthostatic Syndrome (fainting and nausea)

Risk ★ or ★★★★★
Consequence ★

Orthostatic syndrome is the medical term for the dizziness and nausea we sometimes feel when we stand up too quickly.

When we stand, the force of gravity pulls blood into our legs. Constant minor balancing corrections ensure our quadriceps (muscles on the front of our thighs) flex regularly. The flexing helps the blood in our legs return to our heart. Otherwise, blood would pool in our leg veins.

In laboratory tests, a majority of young, healthy people kept in a relaxed vertical position (sitting on a bicycle seat without anything to brace their legs against), suffered orthostatic syncope (fainting) in under 60 minutes, sometimes in under 5 minutes.

Contrary to popular belief, constrictive harnesses aren't a contributing factor. In fact, comfortable harnesses may increase the likelihood of hanging motionless.

The risk is high for vertical suspensions where the legs dangle, nonexistent for suspensions where the legs are above the torso.

Reducing risk

- Avoid suspensions that place the legs significantly lower than the head.
- When suspending your bottom vertically, consider folding her leg under her or tying her in a way that encourages her to use her leg muscles (such as wrapping rope around the sole of her feet so she can push against it some).
- When your bottom is standing in partial suspension, don't allow her to lock her legs into a fully extended position. Monitor her regularly to ensure she keeps her knees at least slightly bent.

Reducing consequence

- If symptoms of orthostatic syndrome occur, instruct her to alternately flex her quadriceps muscles.
- If you're able to, raise her legs.
- Remove her from bondage.
- If she faints, remove her from bondage immediately.

Safety issues to understand but not worry about

Humans are relatively poor judges of risk. As a population, we tend to underestimate risks we accept (car accidents, drowning, syphilis) and overestimate risks of spectacular occurrences (plane crashes, terrorism, the latest headline-grabbing disease).

If you spend any time on any Internet forums, you're likely to see alarming posts about the following safety issues. They're described here so you can understand them enough to avoid them and to know not to worry about them excessively.

Rather than focus on these issues, concern yourself with the mostly likely cause of accidents: human error.

Broken rope

Except for the issue covered in "Sawing through the bight" (which I'd consider a human error more than a rope failure), statistically, ropes don't break during bondage.

With the exception of the overhead rope holding the carabiner (see "Hanging the ring" on page 18), the weight of a suspended bottom is well-distributed across many ropes.

Thus, the risk of a rope breaking during play is very low.

In practice, ropes tend to break one strand at a time (by wear). Since shibari virtually always uses doubled rope, a broken rope always has a backup. Thus, the much-feared sudden drop is relatively unlikely.

Reducing risk

- Retire worn ropes.

Reducing consequence

- Keep suspended bottoms close to the floor.

Hardware failure (Breakage)

Hardware failures are much-feared, much-discussed events that virtually never occur.

You'd have to go out of your way to break even the flimsiest, most obviously unsuitable piece of hardware, let alone the regular or heavy-duty kind.

My advice is to obtain hardware you're comfortable with and stop worrying about it. But, if you're the type to worry about hardware failure, you'll worry no matter what I write. Just try not to think about the fact that your indestructium-alloy suspension ring is held up by a few loops of twisted weeds.

Reducing risk

- Use steel hardware rather than aluminum. See "Aluminum or steel?" on page 16.

- Use over-engineered hardware that exceeds the requirements for a safe working load by an order of magnitude. (Everybody does that anyway.)
- Where possible, double up hardware.

Reducing consequence

- Keep suspended bottoms close to the floor.

Suspension trauma

If your bottom develops orthostatic syndrome (faints) *and* her bondage keeps her in a vertical position *and* you leave her in a vertical position for a significant period of time (i.e. hours), suspension trauma develops.

Suspension trauma (aka Harness Hang Syndrome) occurs because the pooled blood in the legs gradually becomes toxic. If that blood returns quickly to the body's core (due to the bottom lying down too quickly), the toxic blood can cause lethal kidney damage or a heart attack.

The belief in the risk of suspension trauma began when articles about suspension trauma (written in the context of rescuing isolated mountain climbers that had been hanging unconscious for hours) were incorrectly extrapolated for applicability to shibari. However, rescue death isn't a risk in shibari because the rescue occurs at the first signs of distress, nausea or fainting, not hours after orthostatic syncope has occurred. Thus, in shibari, the accumulation of poisonous blood in the legs never occurs.

If suspension trauma happened immediately, soldiers that fainted while in formation would wake up dead... instead of covered in grass stains.

Reducing risk

- Don't support the head for vertical suspensions to ensure you can quickly detect if your bottom faints.
- Don't leave your bottom unattended for hours while in suspension (does this seem obvious?).

Reducing consequence

- After removing your fainted bottom from vertical bondage, don't let her lie down. Instead, keep her seated until she recovers.

This rope showed signs of wear before breaking

12

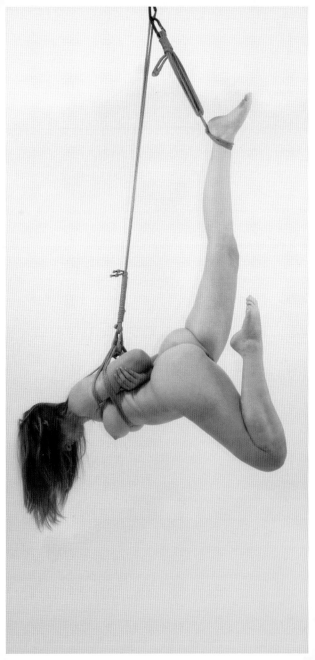

Anchor points

Before attempting rope suspensions, you must have anchor points that you trust absolutely.

No matter how you create your anchor points, be certain that they can hold significantly more than the weight you intend to suspend, even if that weight bounces or moves.

Without the guidance of engineering calculations, most people establish "certainty" by gut feel – your requirements may be much higher or lower than those of another, even if both anchor points are more than adequate.

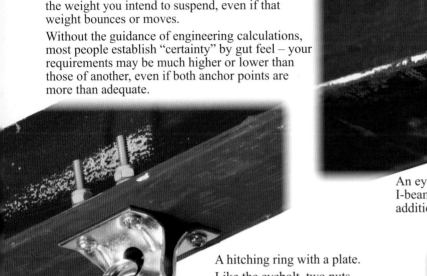

An eyebolt mounted in a steel I-beam. Some people prefer the additional security of cast eyebolts.

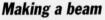

A hitching ring with a plate.

Like the eyebolt, two nuts hold each piece of hardware. Attach one regular nut, then add a locknut to ensure that neither spin off with use.

Exposed hardware makes for easier inspection.

Quick links are easy to install, easy to remove, and have strength similar to a link of welded chain.

Making a beam

If you don't have a beam within reaching distance, you can make one.

Bamboo is a traditional choice, but is very likely to split in dry climates (especially during the heating season). Once bamboo splits, it loses virtually all its load-bearing strength.

- Steel pipe is a less traditional but stronger (and possibly cheaper) alternative to bamboo.
- Thick wooden beams have a traditional appearance, but are bulky and heavy. Beware of damaging the rope on the beam – fillet (round) the edges and sand all irregularities.

You can infer many techniques for installing a beam from *The Better Built Bondage Book.*

Learn more

The Better Built Bondage Book includes an "Anchor Points" section that describes installing anchor points in a variety of materials and locations.

The "Understanding Materials and Design" section covers safety factors, material failure, unbalanced forces, simple harmonic motion, single points of failure… and how to keep these issues from ruining your day.

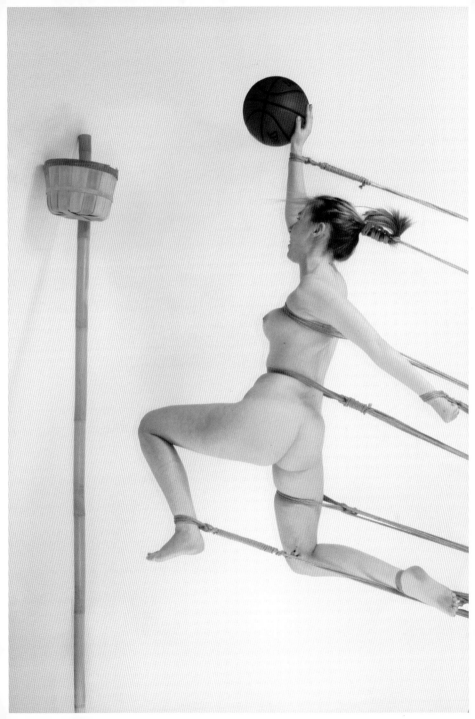

Suspension hardware

Unless you have an overhead beam you can reach standing on the floor, you'll likely need suspension hardware.

Don't stress over your choice - if you choose and use your hardware with common sense, it's extremely unlikely to fail.

Rings

Large steel rings let you run many turns of rope with less risk of jamming. Generally, hardware stores don't carry O-rings larger than 75 mm in diameter - if you can't find anything larger, use carabiners instead.

Sources for rings

Shibari stores may source custom-made rings or some of the other items on this list.

- Marine supply stores sell reasonably large rings, but only if they sell for ocean-going vessels. The stores are often quaint, locally owned, and have little or no Internet presence. Non-coastal stores aren't likely to carry rings larger than 75 mm in diameter.
- Playground suppliers sell aluminum hanging rings for children. The fiberglass equivalents for adults are less appropriate. Hanging rings are a specialty item, so you'll have to do some searching.
- Welders and machinists can make customized rings for you. As a guide, ask for 13 mm diameter steel rod, bent into a circle with a 125-175 mm inner diameter, welded seamlessly and free of burrs.

Other Hardware

Complete Shibari uses a small set of hardware. However, many people appreciate the convenience that other hardware offers. Among the specialty hardware to consider:

- pulleys
- winches (worm gear, electric, etc.)
- belays
- Specially designed suspension rings with multiple sections to minimize rope jamming.

Doug's choice

- 1 specialty O-ring with a 160 mm inner diameter
- 5-7 aluminum carabiners
- 1 steel carabiner

I prefer my largest O-ring because it accommodates the most suspension ropes without binding.

My aluminum carabiners have curved gates and no sharp edges to catch ropes. I find locking-gate carabiners cause me more problems than they solve.

The wire gate on my steel carabiner fits comfortably under my belt and gives me a place to clip the other carabiners for easy access.

However, I use all hardware use styles described in "Suspension Skills" on page 26, if only because it's fun to clip and unclip carabiners.

Carabiners

Carabiners let you hold a small amount of rope and easily unclip when you require. Carabiners may have special features such as curved gates (to give a larger opening for inserting rope), locking gates (to keep the gate from opening accidentally), and variations on D or oval shapes.

Aluminum or steel?

Aluminum carabiners are usually intended for mountain climbing and other activities where weight is a factor. Thus, aluminum carabiners are more likely to be stamped with a load rating than steel equivalents.

However, similarly sized, unrated steel counterparts are metallurgically stronger.

For comparison, the ultimate strength (breakage stress) in tension for aluminum alloy 6061-T6 with 1% magnesium is 290 MPa; annealed stainless steel, at 620 MPa, is twice as strong.

Aluminum's yield strength (deformation stress) of 255 MPa is similar to steel's 275 MPa. However, the difference between the yield strength and ultimate strength causes steel to stretch visibly before failing while aluminum snaps with little warning.

Further, load cycling and casual impacts (such as carabiners banging together in a toy bag) cause microscopic fractures in aluminum, a vulnerability to which steel is very resistant.

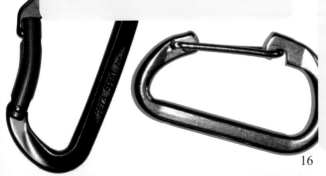

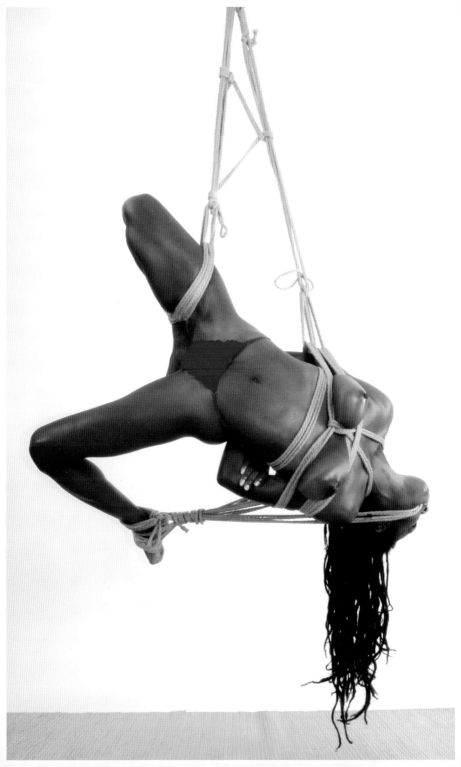

Hanging the ring

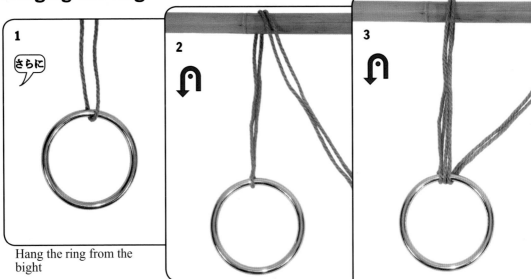

1

さらに

Hang the ring from the bight

2

3

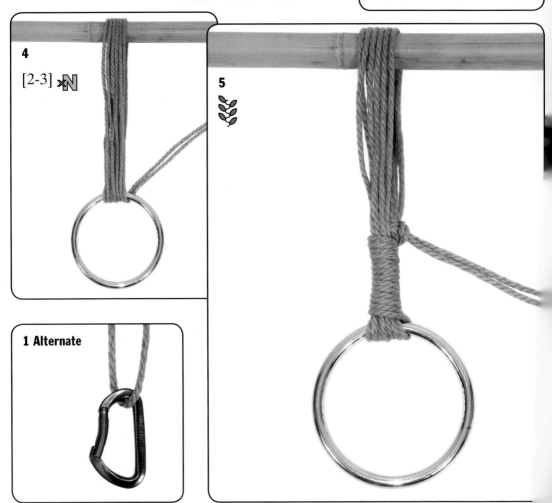

4

[2-3] ×N

5

1 Alternate

18

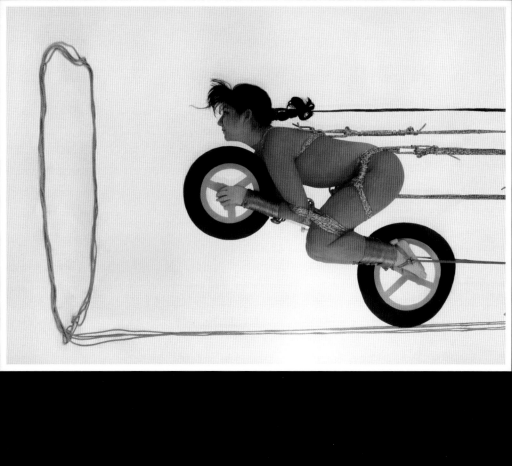

Understanding suspension physics

Mechanical advantage I – Pulley ratios

Pulleys act as load dividers to let you lift objects using less force.

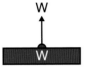 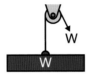 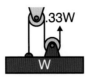 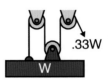

Pulley arrangements starting at the bottom tend to have pulley ratios of 1, 3, 5…

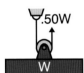 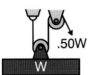 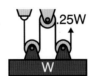 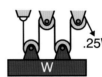

…while arrangements with the ropes starting at the ceiling tend to have pulley ratios of 2, 4, 6…

Mechanical advantage II – Friction in pulleys

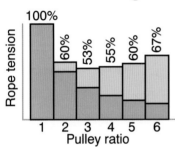

Pulley ratios presume frictionless pulleys. In reality, each pulley adds friction. The rope-on-rope pulleys used in shibari produce a great deal of friction. The actual friction varies with many factors, but even with a conservative 10% friction, the benefit of many pulleys disappears quickly.

 Tension due to weight
 Friction (assuming 10% of weight per pulley)

Division of load I – Multiple lift points

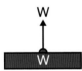

A weight, W, hanging straight down, puts a tension, W, on the rope.

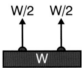

A second rope can divide the tension in two…

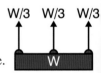

…a third, by three.

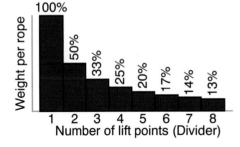

As additional ropes are added, the tension on each rope can be reduced, but by a smaller increment each time, until the difference of adding a rope becomes almost imperceptible.

However, if the ropes don't take tension evenly, additional ropes may do nothing (or reduce the effectiveness of other ropes).

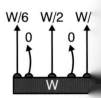

Division of load II – Pressure

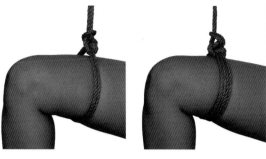

Division of load also applies to distributing pressure across an area…

…with the same problems of distributing load evenly.

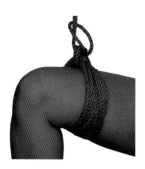

Division of load III – Time efficiency

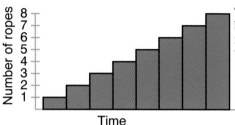

Number of ropes

Time

Though each additional rope benefits less and less, it takes roughly the same amount of time to add…

…and remove. So make each rope count!

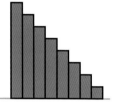

Load distribution I – Flexible bodies

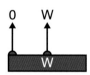

With a rigid structure and inelastic rope, imbalances in loading could mean that a single rope could end up taking the entire load.

Stretchy rope and a flexible body help distribute load more evenly amongst the ropes.

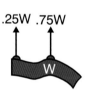

Load distribution II – Counterbalance

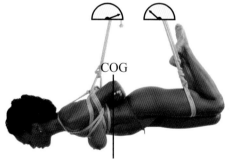

Position affects weight distribution and center of gravity (COG).

In this simple two-point suspension, most of her weight is on her chest harness.

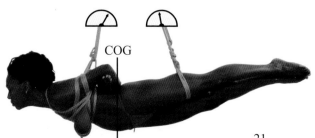

Straightening her legs acts as a counterbalance, reducing the weight supported on the chest harness and increasing the weight on the leg loop.

Angle of pull

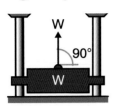

Lifting a weight, W, with a 90° pull (straight up), requires a rope tension, W.

At 45°, the rope tension rises to 1.42W.

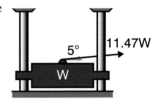

As the direction of pull gets further from the direction of gravity, the rope tension rises dramatically…

…until at 5° (almost a sideways pull), the rope tension to lift the weight is 11.47W!

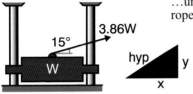

For off-angle pulls, the hypotenuse is the rope tension, but only the y component adds vertical lift.

Sling I – Rope cradles

Rope cradles divide the tension in two. However, the ratios are the same as for a single-rope lift.

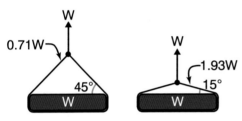

The tension in the cradle stretches the rope and crushes the suspended object.

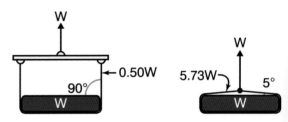

In the 5° sling, the object will be compressed as if it's 11.47 times as heavy as the 90° cradle (5.73W instead of 0.50W).

Sling II – Comfort

Rope angle is a major predictor of a suspension's comfort.

Comfortable

Less comfortable

Uncomfortable

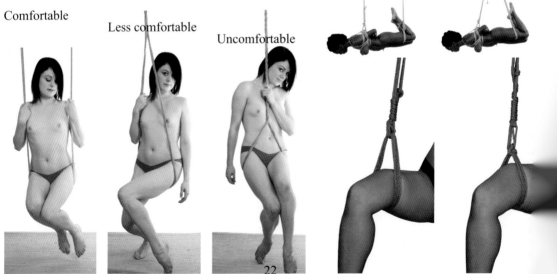

Slings III – Orientation of 2 objects

 ~35° The tension in a sling depends on the orientation of the object within. Two cylinders side-by-side in a sling create more rope tension…

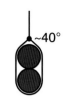 ~40°

…than two suspended vertically, even though the length of the rope sling is unchanged. The steeper angle predicts that the second arrangement will have less tension. (Note that the *angle* determines tension, not the distance of the rope from the body or the area under the rope.)

Slings IV – Orientation of 3 objects

Slack

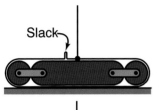

The object within this sling is similar to the upper body when bound in a Box Tie – two arms and a torso.

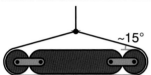 ~15°

When suspended, the angle is very shallow, indicating great rope tension.

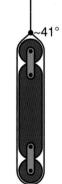 ~41°

Rotating the object 90° increases the rope angle (reduces the tension), without changing the sling's rope length. Again, notice how the rope gap isn't a predictor of rope tension (this configuration has very little gap), but rope angle is.

Side suspensions tend to be more comfortable, particularly for tight chest harnesses or broad-shouldered individuals.

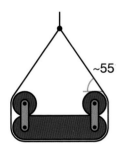 ~55

However, if the bottom's arms can rotate back (such as they do for "Hogtie Suspension" on page 80), the tension is reduced dramatically. Small, flexible bottoms are usually best able to do so, though few can move their arms fully out of the way.

Bundles of objects will tend to stabilize where the tension is lower (and rope angle is greatest).

Slings V – Hanging vertically

Hanging an object vertically in a sling also creates a rope angle that suggests relative tightness.

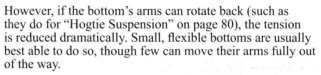
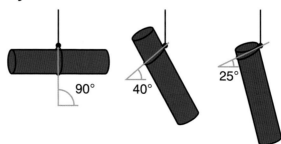

90° 40° 25°

Deflecting rope I – Lifting

A rope can't withstand even the slightest side load without deflecting (excepting rope stiffness). In fact, it would take an extreme amount of rope tension to prevent deflection. Conversely, slight deflecting force on a rope can lift a heavy weight.

Deflecting rope II – Cinches

Since cinches pull in the middle of ropes, slight tension can put great tension on a rope. Suspending with a cinch can put extreme tension on rope (and similarly extreme pressure on the body within the rope).

Deflecting rope III – Support area

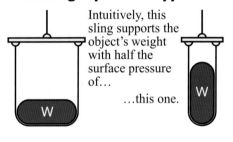

Intuitively, this sling supports the object's weight with half the surface pressure of…

…this one.

However, horizontal rope can't support a vertical load without deflecting. The rope on the bottom of this (idealized) sling is perfectly horizontal.

In reality, the vertical lift area (and pressure caused by it) is the same for both slings.

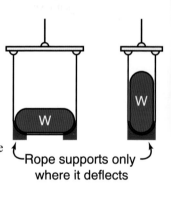

Rope supports only where it deflects

Bending moment I – Long spans

To keep from sagging due to its own weight, a suspended beam generates internal stress. The weight in the middle of the beam must be supported by the ends of the beam, so the bending moment increases with longer spans.

Adding more lift points eliminates long spans, greatly reducing bending moment (and internal stress).

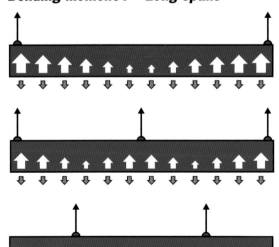

Strategically placing the lift points can also reduce the maximum bending moment.

Bending moment II – Human body

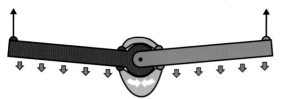

In the human body, muscles produce the torque necessary to rotate bones relative to each other, countering bending moment. Muscles can only contract, but by pulling a lever, they can produce torque.

In this simplified suspension, the stressed muscles will always be on the bottom.

(Muscles used to resist a cantilever effect will be on the top; hyperextended joints don't stress muscles, but risk other types of injuries.)

Scale I – Proportional mass

As objects grow, they become proportionally weaker.

For example, mice, humans, and elephants have proportionally similar bone sizes. However, a mouse that fell 3 m would likely scamper away while a human would be at serious risk of a break or a sprain. If an elephant jumped, it would break its leg.

Similarly, whales are so large that without the support of water, their ribs might break; ants can lift ten times their weight because they're very small; if you doubled every dimension of your kitchen table, it would eventually collapse under its own weight.

The reason is scale.

The mass of a proportional object grows by the *cube* of its height, while the strength grows by the only *square* of its height. Thus, as an object grows, it becomes proportionally weaker.

Obviously humans don't have the size range of mice and elephants, but even

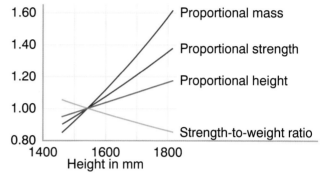

Effect of scale (Baseline person, 1550 mm tall)

considering the typical range of humans females, the mass can vary by almost a factor of two, for women of the *same shape*.

Note that scale applies to two people of the same proportional shape, not people of different body types. Differences in proportional muscle mass, body fat, limb length, etc., make a major difference in a person's ability to be suspended, independent of scale.

Scale II – Statistical norms

Shibari was originally applied on Japanese women. However, as a population, Japanese women are considerably shorter than American women and, due to scale, weigh dramatically less.

When suspending someone, remember that a few centimeters extra height makes a difference, even if the body shapes are similar.

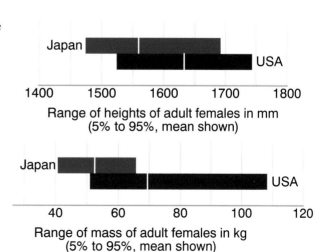

Range of heights of adult females in mm
(5% to 95%, mean shown)

Range of mass of adult females in kg
(5% to 95%, mean shown)

Suspension skills

Are you Ready?

Before you start rope suspension, answer the following questions:

- Have you practiced the techniques in *Complete Shibari: Land* enough that you can quickly and consistently reproduce the ties without referring to the book? (The lessons in *Land* won't be repeated in *Sky*.)
- Are you (or an alert helper) physically strong enough to lift and lower at least half your bottom's weight?
- Can you move your own body easily and nimbly?
- Is your bottom fit and limber?

- Are you able to tie quickly and confidently?
- Do you remain calm and clearheaded during emergencies and unexpected events?

If you answered "no" to any of these questions, then you and your bottom are at increased risk of experiencing an injury during rope suspension. If you answered "no" to two or more questions, seriously consider the risks and consequences of performing rope suspensions, both for you and your partner.

Rope suspension isn't for everybody. In fact, many of Japan's (and the world's) top rope artists never perform rope suspensions.

Be realistic

Many beginners have visions of flogging, teasing, or having sex with their bottom while suspended. Although technically possible, such activities are rarely done because:

- Struggling upsets carefully placed ropes.
- Moving greatly increases the likelihood of ending the suspension with an emergency removal.
- The typical amount of time in rope doesn't allow for extended play. (Do you really want to brag that you can have sex, even with really short suspensions?)
- Many bottoms actually prefer to lie calmly while in rope.

For more energetic play, consider using a leather sling. You can build your own using plans from *The Better Built Bondage Book*.

Partial and full suspensions

Partial suspensions let her partially support her own weight. Partials are more forgiving because errors usually don't have to bear as much weight...

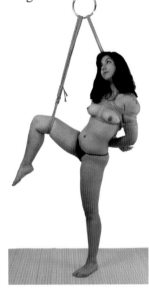

...unless she tires, loses her balance, or lifts her legs up and fewer ropes take more weight.

Full suspensions lift her full body weight off the ground (and prevent her from supporting herself).

26

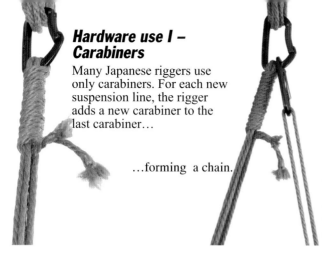

Hardware use I – Carabiners

Many Japanese riggers use only carabiners. For each new suspension line, the rigger adds a new carabiner to the last carabiner…

…forming a chain.

Each carabiner holds only one suspension line and the next carabiner. Linked carabiners are attractive, unlikely to jam, and easy to remove in the proper order.

Hardware use II – Rings

Many riggers use large-diameter rings. The large diameter helps minimize (but not prevent) binding, while allowing ropes to be added and removed in any order.

Hardware use III – Rings & carabiners

Some riggers use a ring, but separate each suspension line with carabiners.

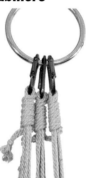

Hardware use IV – No hardware

Finally, if you have an overhead beam within easy reach (or can install a temporary one), you may need no hardware at all!

Proper ring height

Set your ring height low enough that you can easily reach , but high enough that you won't bang your head on it.

Beware of setting your ring to a height that requires step stool – set it within reach, even your bottom is l.

A third hand

If you need to hold a line taut while freeing a jammed rope, you can use your teeth as a third hand.

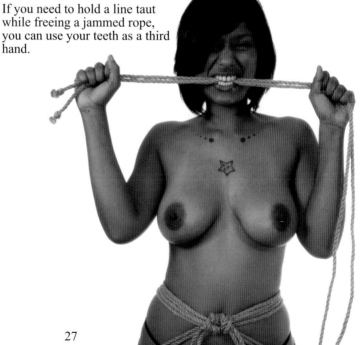

27

Suspension types

Step-in suspension

The body is suspended sequentially until the bottom is fully suspended. Typically the torso is lifted, then the feet. This is the most traditional form of suspension.

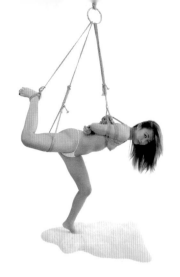
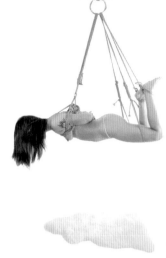

Pull-out suspension

The bottom rests or lies on a support (chair or bench) while all suspension lines are attached. The support is then pulled out from under the bottom.

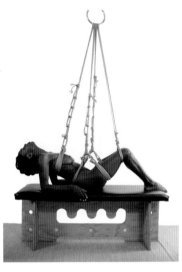
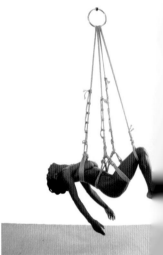

Hoist up suspension

The bottom rests on the floor while all suspension lines are attached. The bottom is then hoisted up into the air using a pulley or winch. This suspension type is the most technically simple, provided the winch doesn't fail or the pulley doesn't slip or jam.

None of the ties in the *Complete Shibari* series use hoist up suspension, but you can adapt any suspension by adding a hoist or winch.

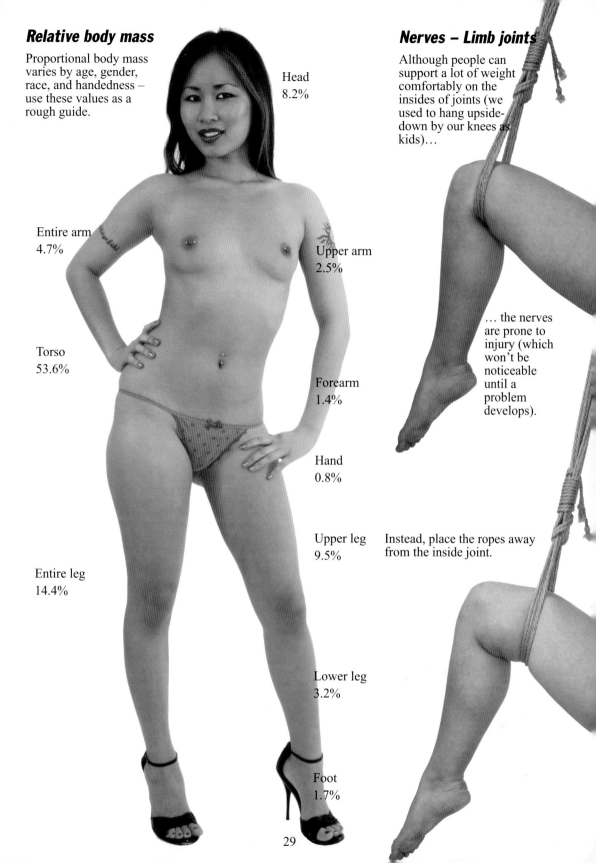

Relative body mass

Proportional body mass varies by age, gender, race, and handedness – use these values as a rough guide.

Head
8.2%

Entire arm
4.7%

Upper arm
2.5%

Torso
53.6%

Forearm
1.4%

Hand
0.8%

Entire leg
14.4%

Upper leg
9.5%

Lower leg
3.2%

Foot
1.7%

Nerves – Limb joints

Although people can support a lot of weight comfortably on the insides of joints (we used to hang upside-down by our knees as kids)…

… the nerves are prone to injury (which won't be noticeable until a problem develops).

Instead, place the ropes away from the inside joint.

Time in suspension

Although she may not consider the suspension to start until the last rope is on, you should consider the suspension to start the moment the first suspension line goes on. Work quickly thereafter.

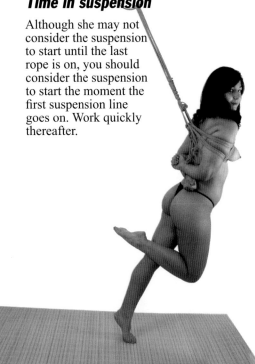

Test your ring

Test your suspension points before using them! You should be confident that they're secure, no matter how you use them.

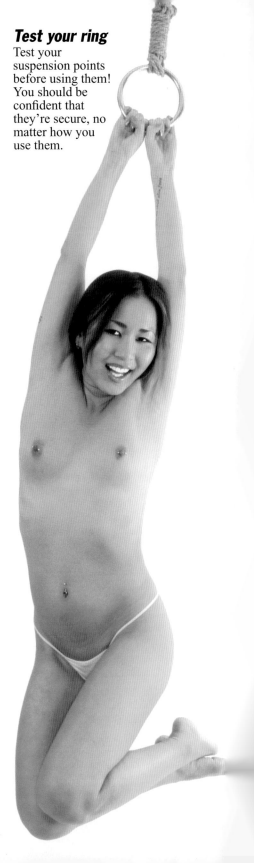

Nerves – Arms

The radial nerve is vulnerable near the intersection of the deltoid, biceps, and triceps.

Rope suspensions tend to put pressure on this area; the natural shape of the muscles tends to push rope toward that area.

Avoiding the area is almost impossible, but be aware of the site.

For signs of damage, see "Safety" in *Land*.

The radial nerve is vulnerable at the intersection of the muscles

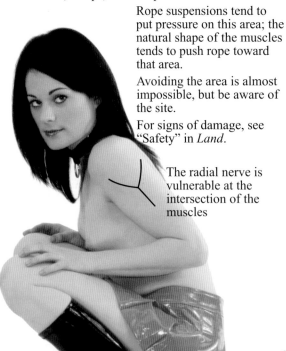

Pullout suspensions I – Performing

Pulling a bench out from under your bottom can be risky if the ropes don't support her as you expect.

For a predictable pullout technique, push your bottom and the bench sideways until the ropes lift her gently off the bench.

Once you've confirmed the ropes are comfortable, pull the bench toward you, then allow gravity to slowly return your bottom to a free hanging position.

This technique ensures you can always replace the bench, should you need to (pushing the bench away from you puts the bench out of your reach.)

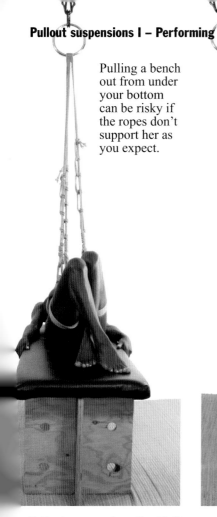
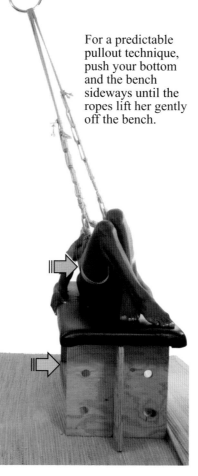
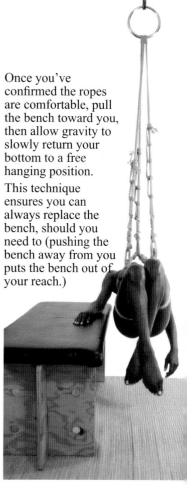

Pullout suspensions II – Ending

Once you pull the bench out, you won't likely be able to slide it back under her easily.

To end a pullout suspension, reverse the process for pulling out the bench – push her sideways, push the bench under her, then pull her and the bench toward you.

Hips and belly

Some people prefer the harness sitting above their hips; some prefer on the hips.

Leave them wanting more

Expect early suspensions to last only a few minutes. Even with skilled riggers, many experienced bottoms consider a 10-20 minute suspension to be "enough". Longer suspension times don't necessarily make a suspension more successful (and some of the most emotionally overpowering suspensions may last under 5 minutes).

If possible, end with her wanting more and wishing she could have stayed up "a bit longer".

Suspension Tie

The suspension tie is fundamental to almost every suspension you'll do. It is exactly a Limb Loop.

Where the Limb Loop is the most complicated tie in *Complete Shibari: Land*, the suspension

tie is the mostly complicated tie in *Sky*. Tie these carefully and practice – many people get confused by the presence of nearby ropes.

Traditional lifts lock the bight during the lift; for safer lifts, lock the bight as you tie.

Style A

This tie is exactly a wrist loop, but with one turn of rope on each side of the center knot on the back of a chest harness.

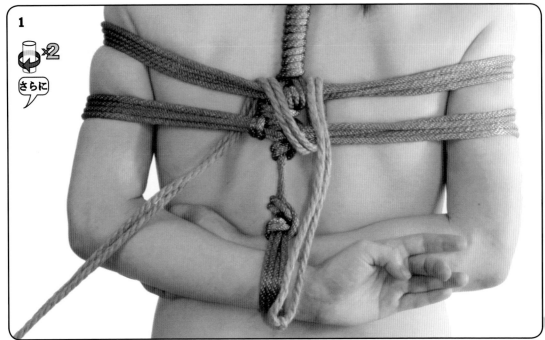

Don't attach the Suspension Tie to cinch ropes – the chest harness could become unintentionally tight. Attach only to the Midrope Loops circling the chest (and arms).

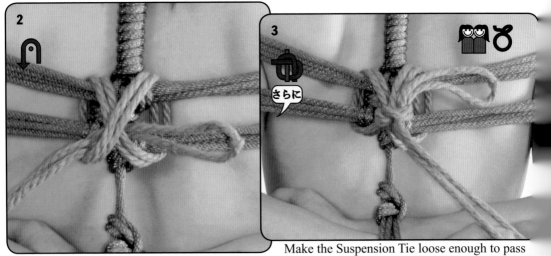

Make the Suspension Tie loose enough to pass rope through the loop.

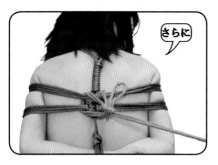

By passing a turn of rope on each side of the vertical ropes, the suspension tie stays properly placed, even with side-to-side tension.

Another view

To eliminate distractions from other ropes, pass a helper's arm (or a piece of bamboo) between the chest harness and the suspension tie's finishing knot.

For this view, the tie was started by passing the bight downward, under the chest harness, rather than upward. Use the method that suits you best.

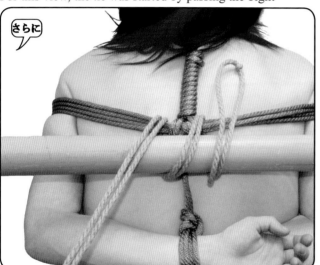

Style B

Use this style for attaching to hip harnesses, the sides of chest harnesses, and other locations where the rope doesn't attach to a plus-shaped intersection of ropes.

1

Lift D begins with a Limb Loop (shown) which becomes locked as part of the lift's construction.

2

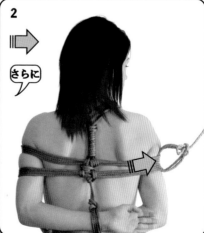

Move the tie as required.

Lifts

Lifts apply a suspension line to a part of the body.

Lift A

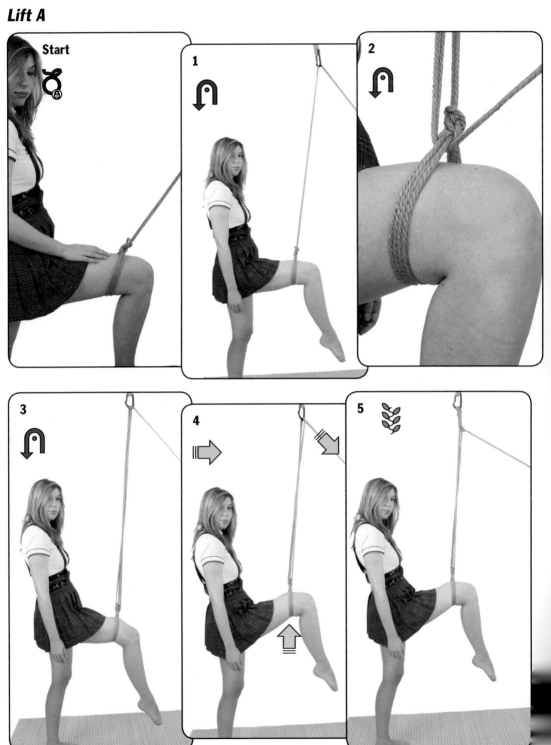

Lift B

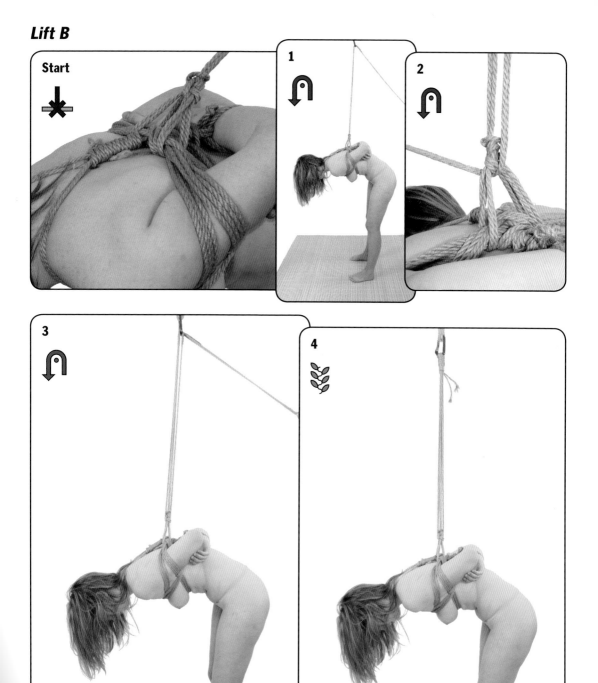

Lift C

This flashy lift includes a loop as a second support point. The support is minimal and the rope is prone to sliding on the ring. Consider using this lift only with small, light bottoms.

Start

1

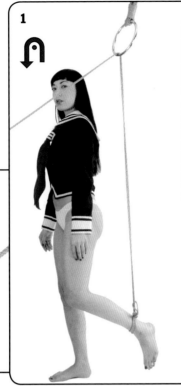

2

さらに

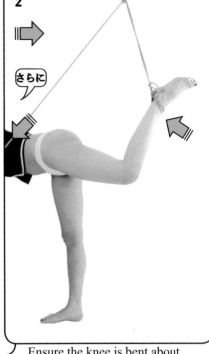

Ensure the knee is bent about 90°. Otherwise, the suspension will sag when the knee *is* bent.

3

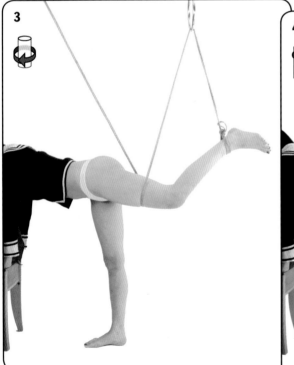

4

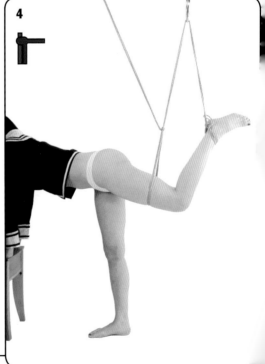

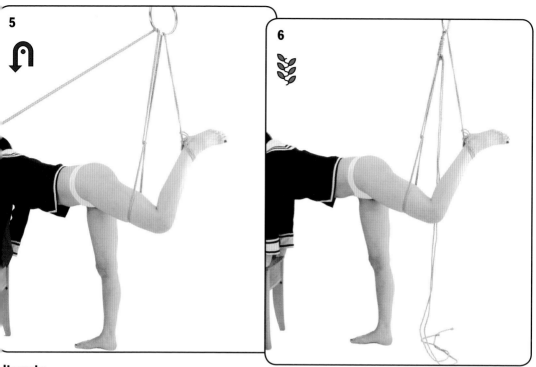

...lternate

...his alternate procedure uses extra rope to provide additional support ...o the suspended area, making it a cross between Lift A and Lift C.

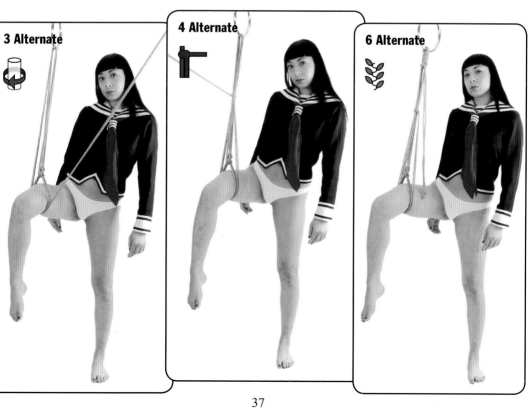

Lift D

This traditional lift locks the Limb Loop efficiently, but greatly increases the likelihood of sawing through the bight.

Steps 2 and 3 use the bight as a pulley, wearing it. If the bight fails, the suspension will fail entirely.

This lift isn't called for in this series, but can be used as a replacement for Lift A.

Start

Traditionalists use a similar technique for Lift B (which has an even greater likelihood of causing rope failure).

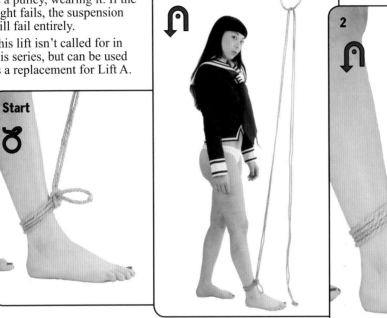

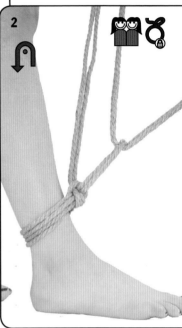

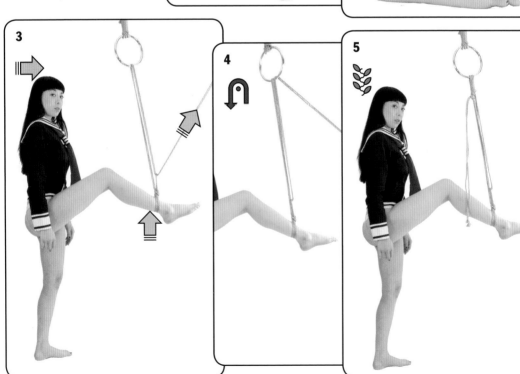

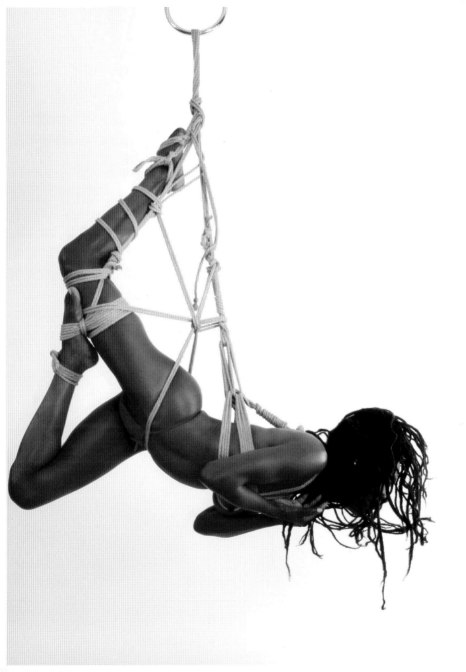

Lowering a weight

To safely end a lift, practice lowering a weight in a smooth, controlled manner.

Start

Attach your loop to a dumbbell. Use a significant amount of weight so that you can't "cheat" on your technique. If possible, use 15-30 kg. Protect the floor with a pillow. If you don't have gym weights, use a pail of sand or kitty litter, a laundry basket full of books, or anything else similarly heavy.

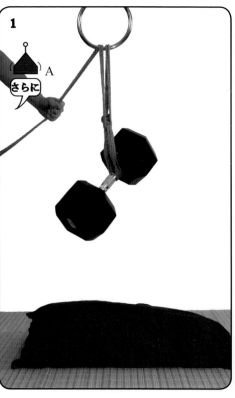

The ring is set low for the photo; consider setting the ring at a normal height for practice. Use caution – dropping the weight could cause damage to the floor or you.

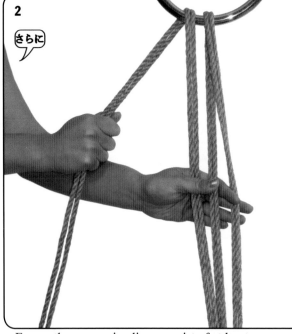

Ensure the suspension lines consist of at least three passes of rope (i.e. load divider of 3 or more).

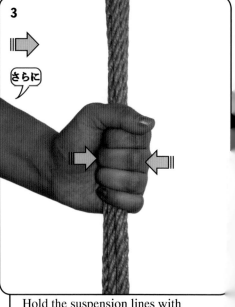

Hold the suspension lines with your non-dominant hand (left hand for most people). This hand is the brake.

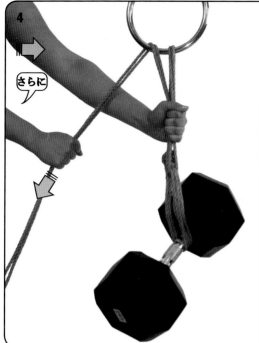

4

さらに

Hold the running end of the ropes with your dominant hand (right hand for most people). This hand is the backup.

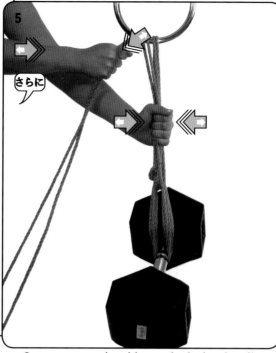

5

さらに

Loosen your grip with your brake hand until the weight lowers slowly and smoothly. Track the rope with your backup hand, but don't let the rope slide.

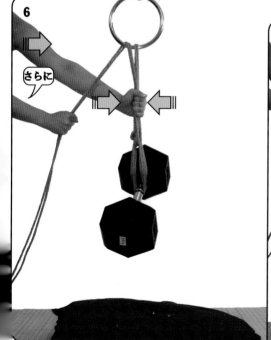

6

さらに

Stop the weight's descent with your brake hand, then slide your backup hand further down the running end of the rope. Don't let the rope slide through both hands at the same time.

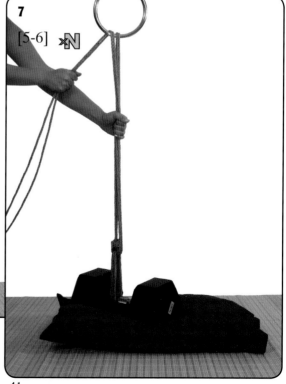

7

[5-6] ×N

Head support

Some people benefit from head support during a suspension, particularly for horizontal, face-up suspensions.

Select a piece of material. The one pictured is 1300 mm by 550 mm.

Fold the material endwise.

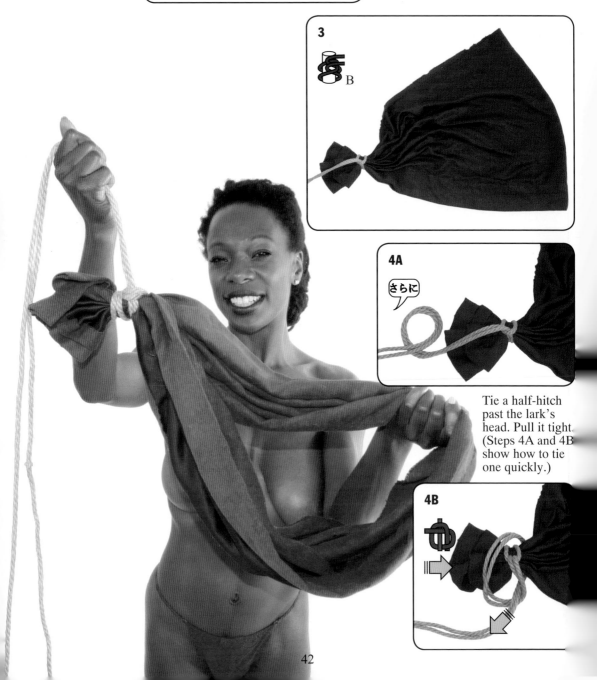

Tie a half-hitch past the lark's head. Pull it tight. (Steps 4A and 4B show how to tie one quickly.)

5

さらに

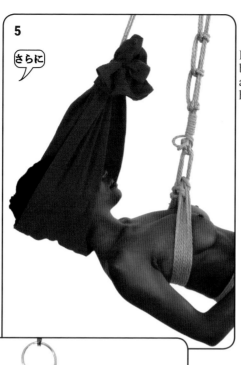

Loop the material
behind her head and
adjust the height to
her preference.

When taking her down, minimize
head jostling by removing the
head support before untying the
suspension line.

6

A

7

さらに

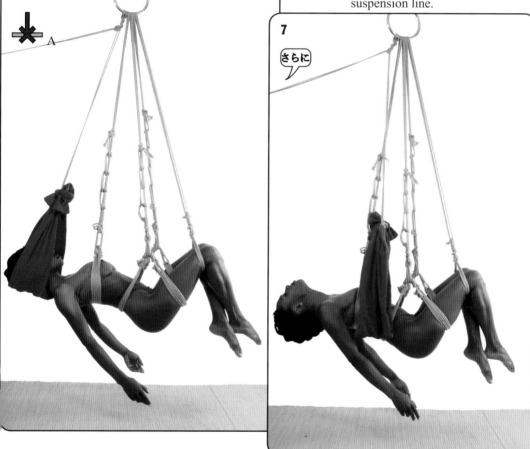

43

Using up rope

Rope suspension will often leave long pieces of leftover rope – much longer than with floorwork – and too long to use up by increasing the length of your vines.

To work efficiently, keep your suspension neat. Clean up each piece of rope before you move on to the next one (but keep track of where each rope ends).

Ultimately, a tidy suspension looks better and keeps you from wasting precious minutes untangling your working rope from stray loose ends.

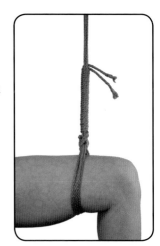

Style A

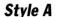

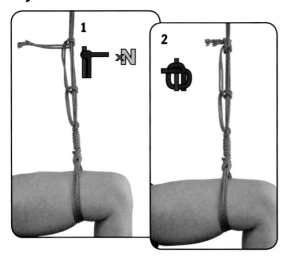

Style B

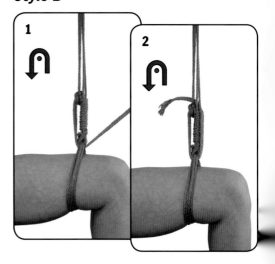

Style C

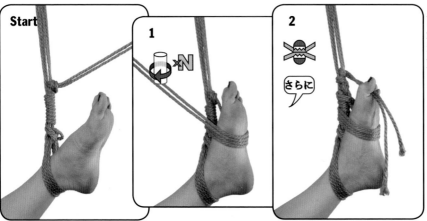

Use up extra rope by wrapping it around body parts.

44

Style D

Start

1

Although styles D and E are shown on the legs, the zig-zagged rope will collapse if the suspension lines get closer.

Style E

Start

1

Style F

Use extra rope to gently provide additional support. See the alternate procedure for Lift C on page 36.

1

さらに

Cleanup can make a simple suspension more impressive.

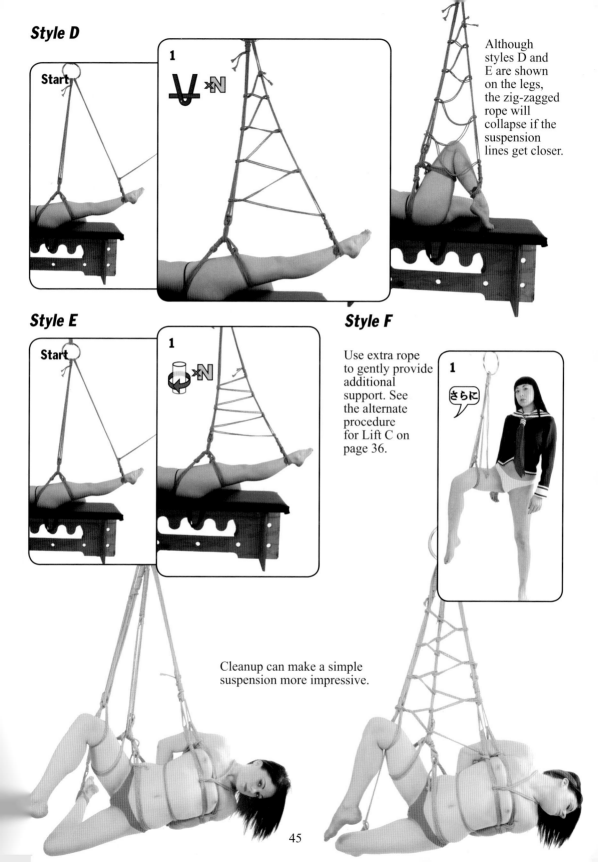

Box Tie

高手小手縛り

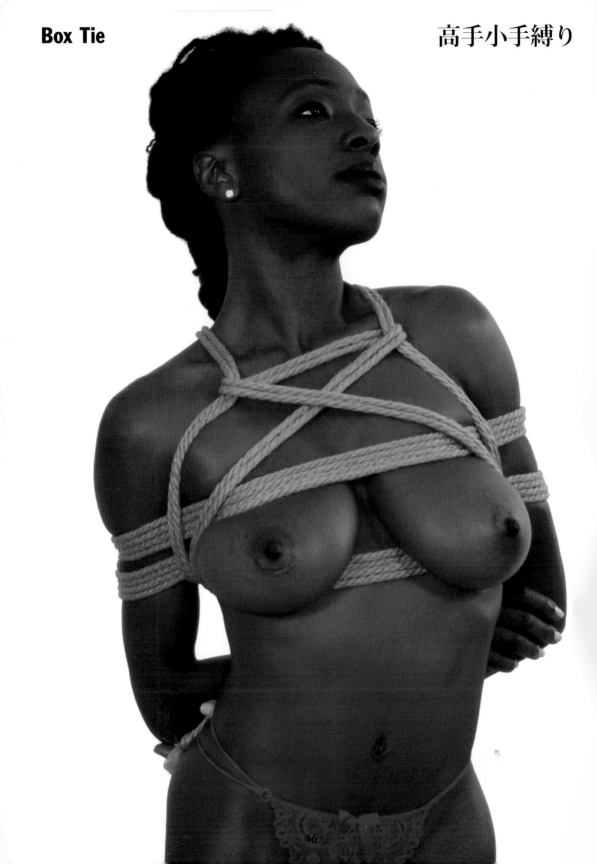

This Box Tie variant replaces the traditional over-the-shoulder V-shaped ropework with a simple, attractive alternative. Some bottoms may find this tie more comfortable for suspensions – the ropes lie further from the base of the neck.

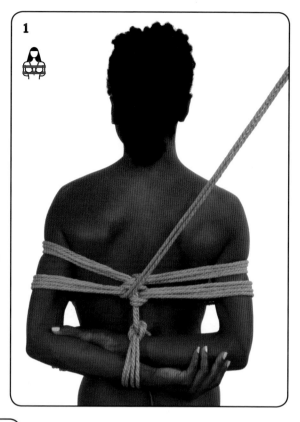

Box Tie. The optional cinch ropes aren't shown.

For a neater appearance, pass the rope under the stem.

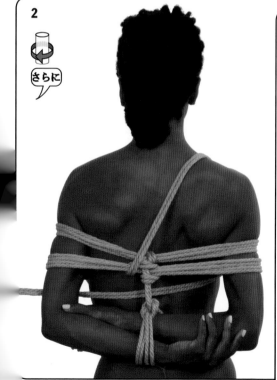

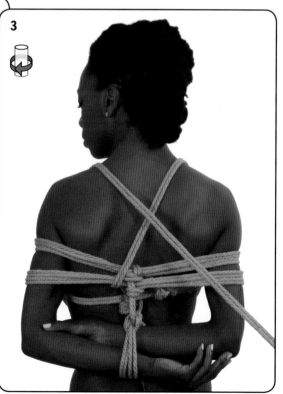

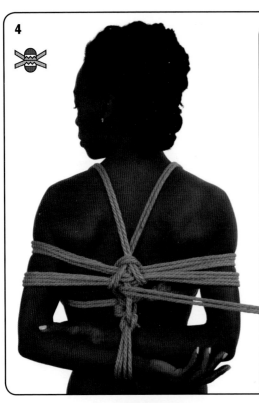

4

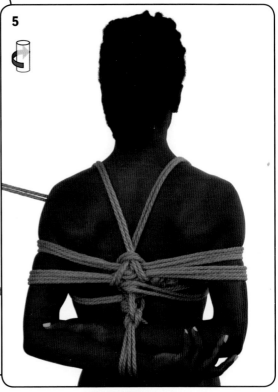

5

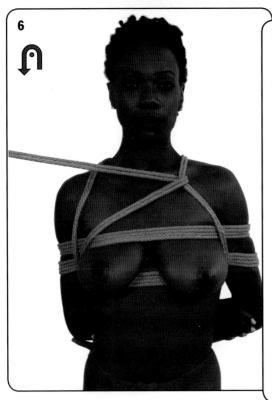

6

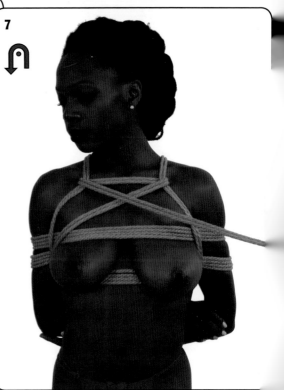

7

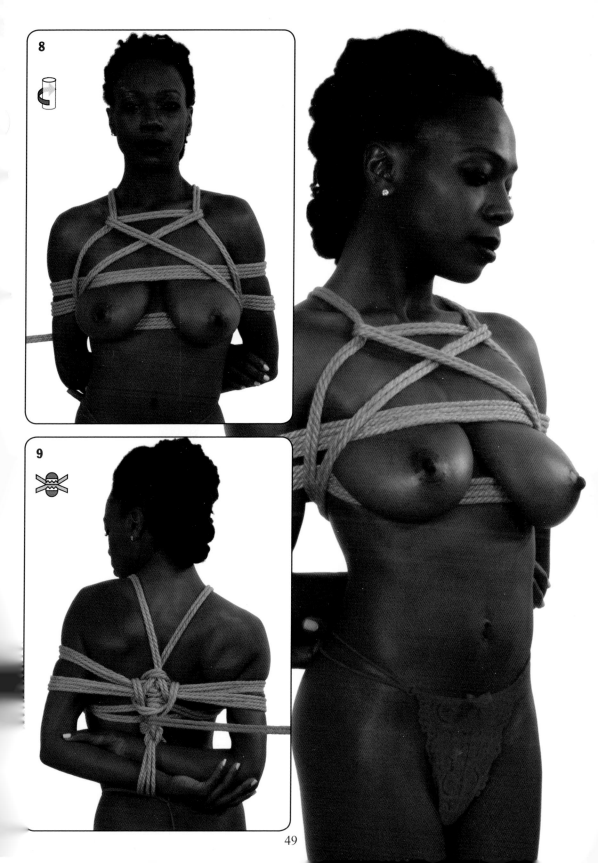

8

9

Chest Harness A

Chest harnesses are similar in function to the Box Tie, but because they don't include the arms, they're typically less stressful for suspensions.

This chest harness has no shoulder harness (although you can add one), so it may be more likely to slide downward.

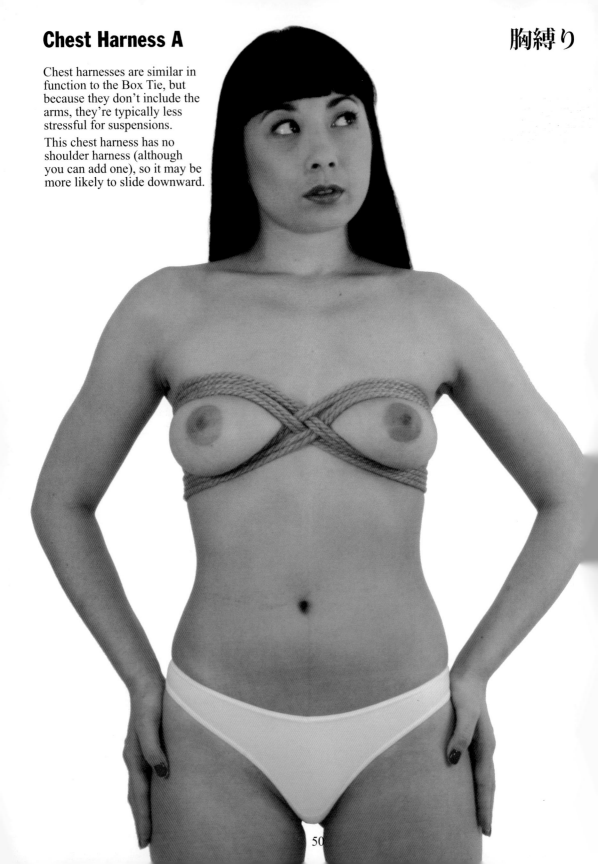

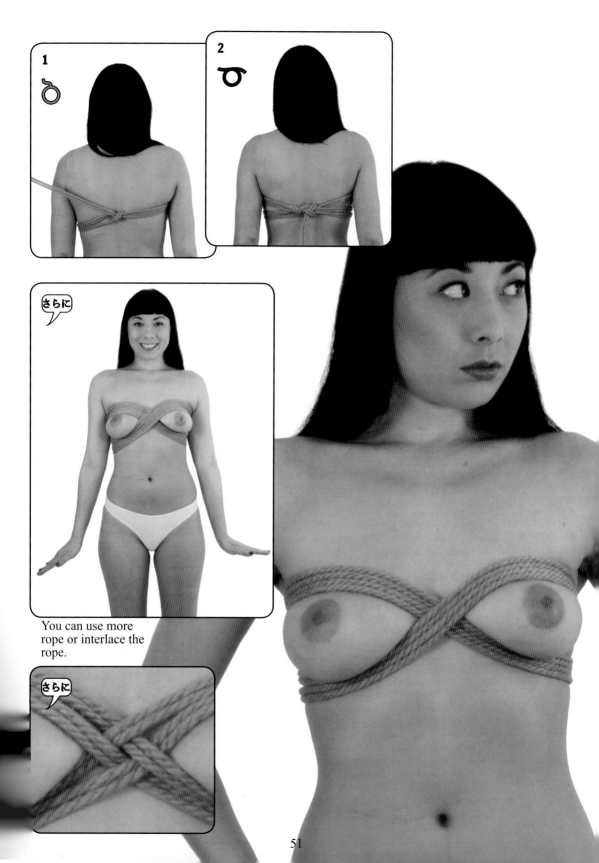

1

2

さらに

You can use more
rope or interlace the
rope.

さらに

51

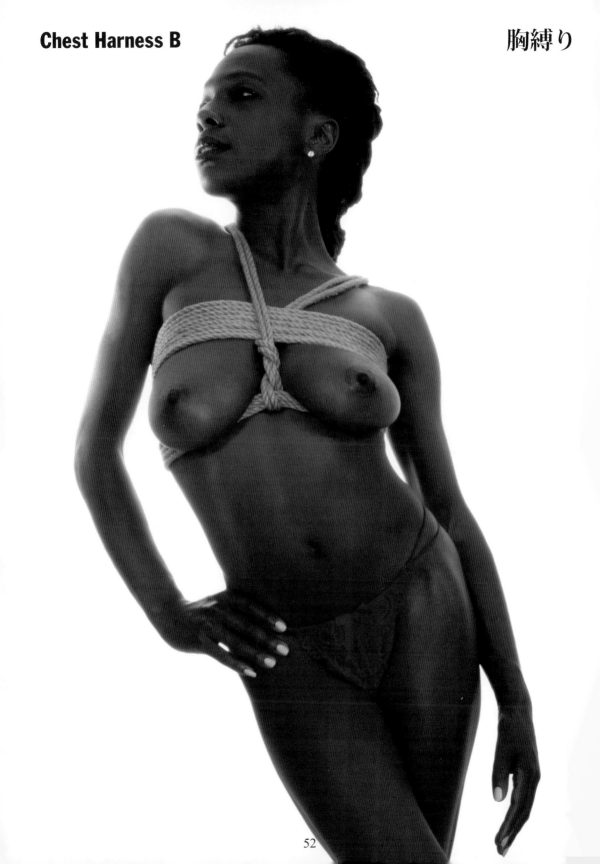

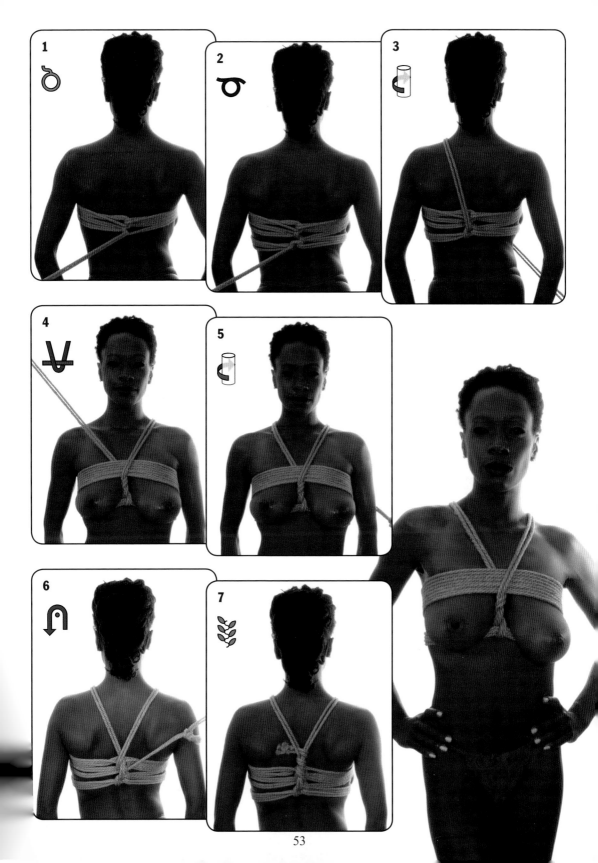

Gunslinger Suspension Harness カウボーイ飾り縄

1

You can lock the loop by wrapping the bight with vines in step 7.

2
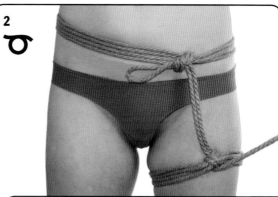

3
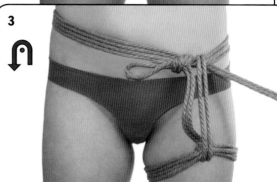

4
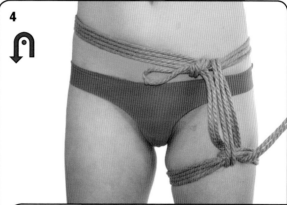

5
[3-4]
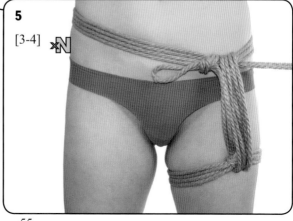

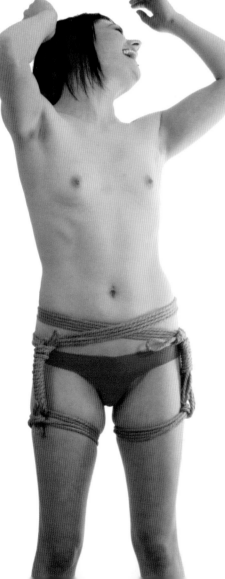

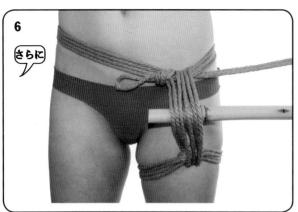

6

さらに

Keep the tension on the connecting rope even and loose.

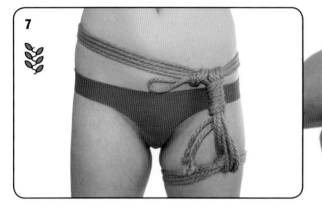

7

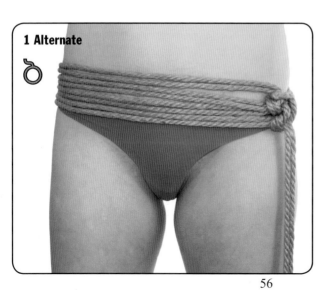

1 Alternate

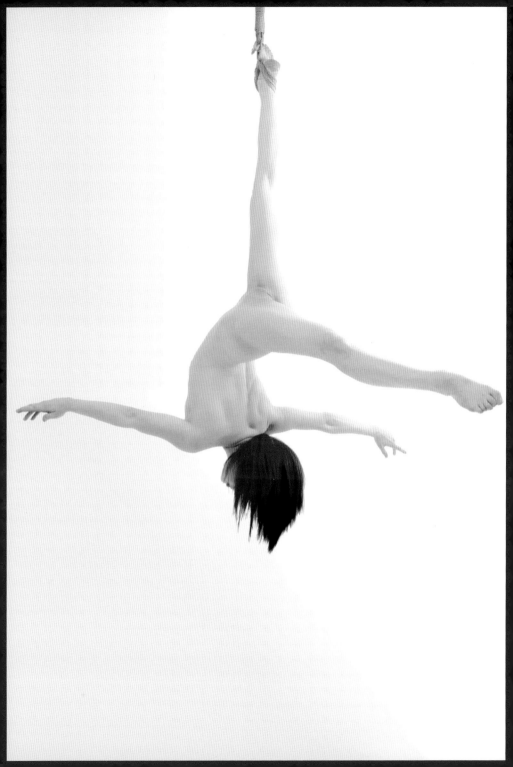

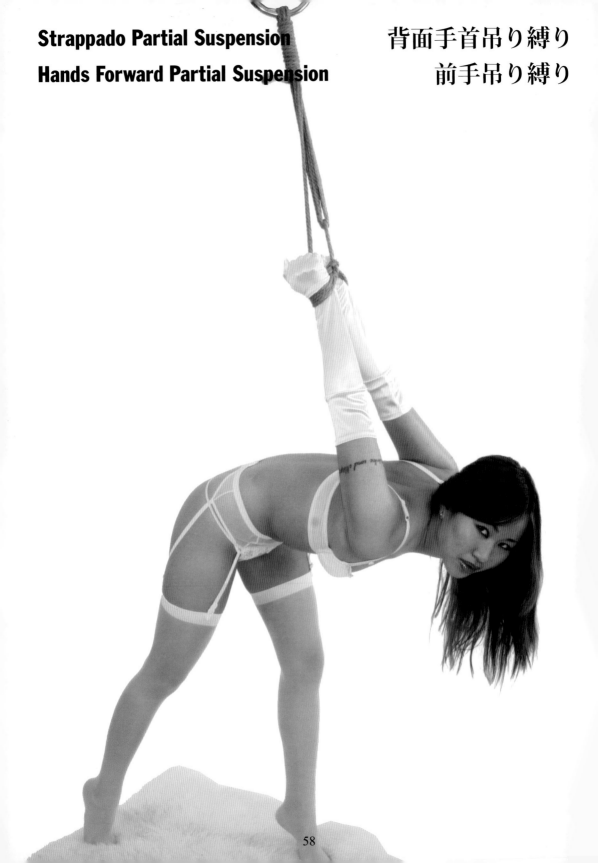

Strappado Partial Suspension
Hands Forward Partial Suspension

背面手首吊り縛り
前手吊り縛り

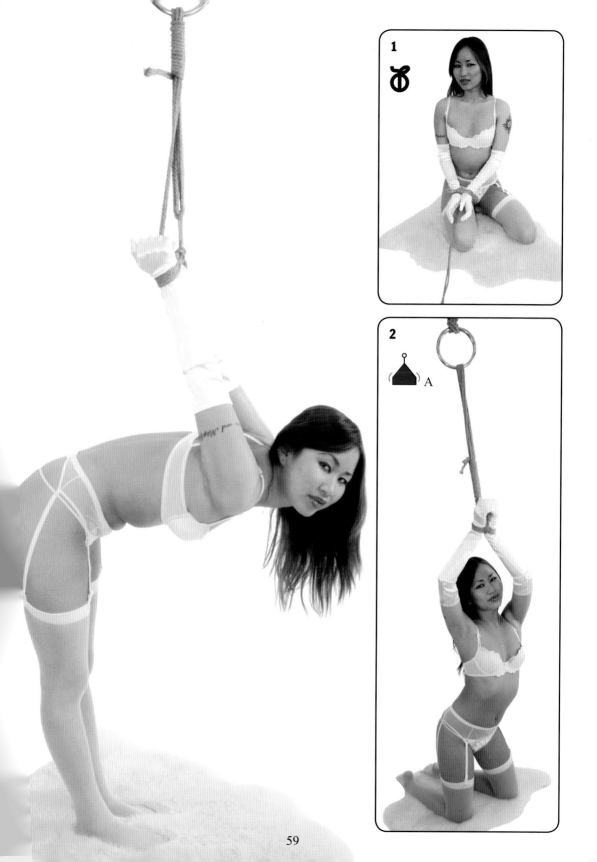

1

2

A

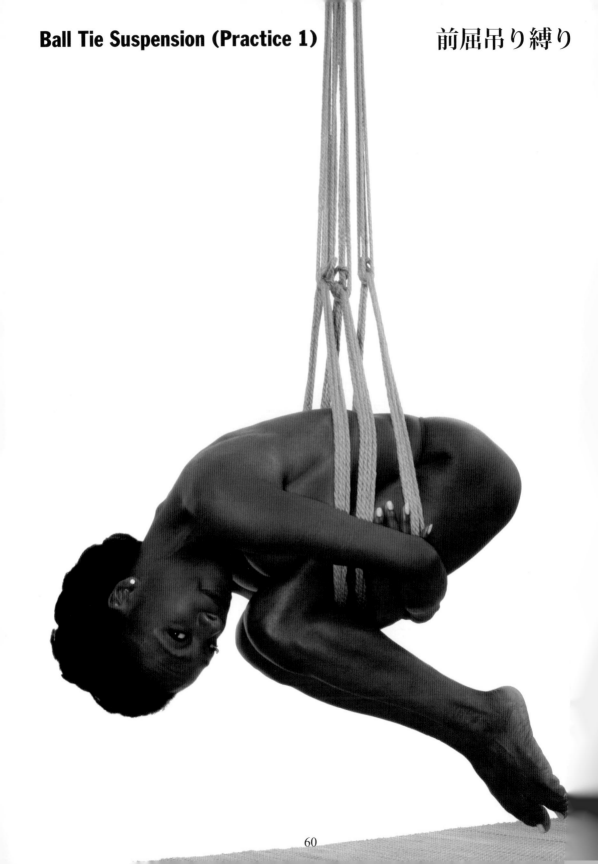

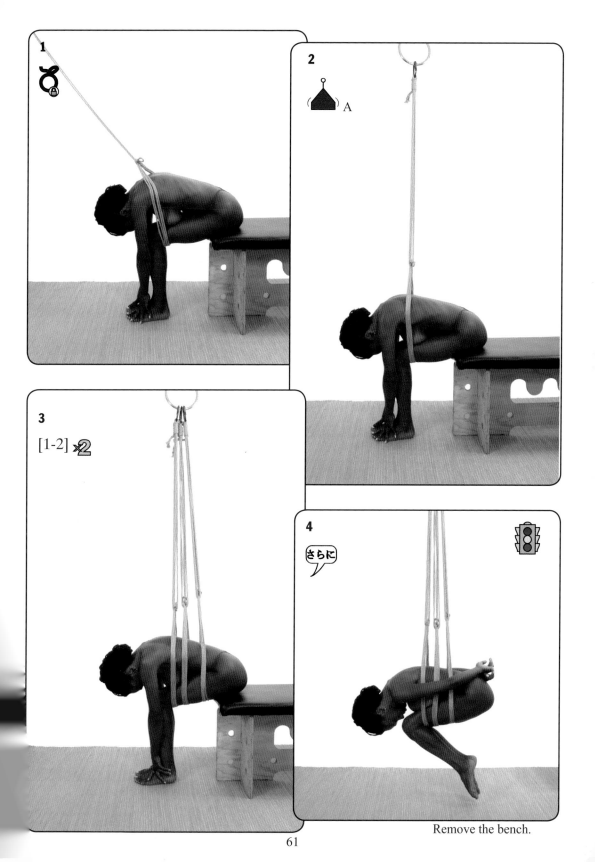

Remove the bench.

61

5

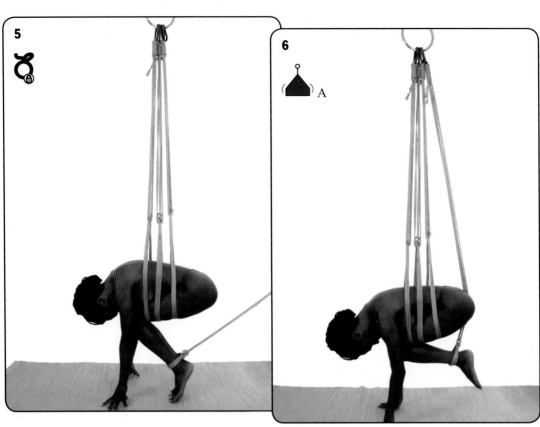

6 A

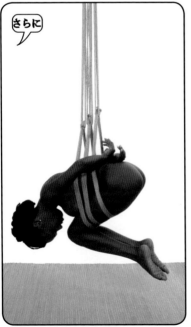

Once suspended, she may tend to tip forward. If so, put more tension on the front ropes.

To end the suspension, undo the ankle ropes and put the bench back. But if she needs to end early, she can simply stand up!

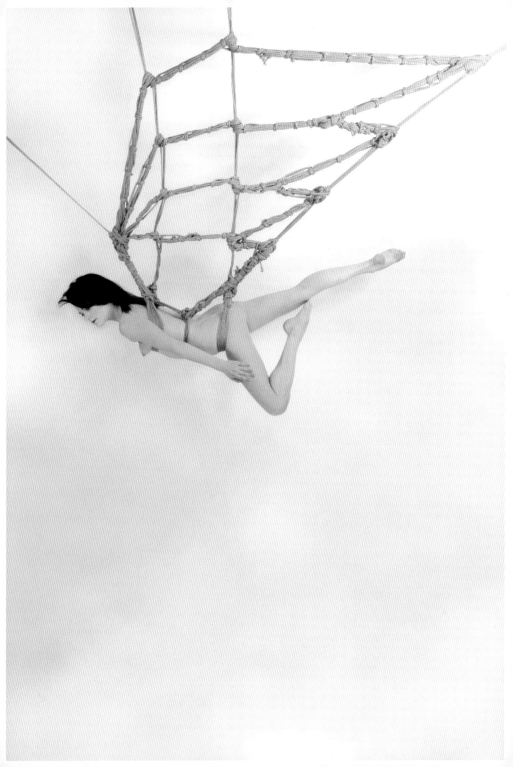

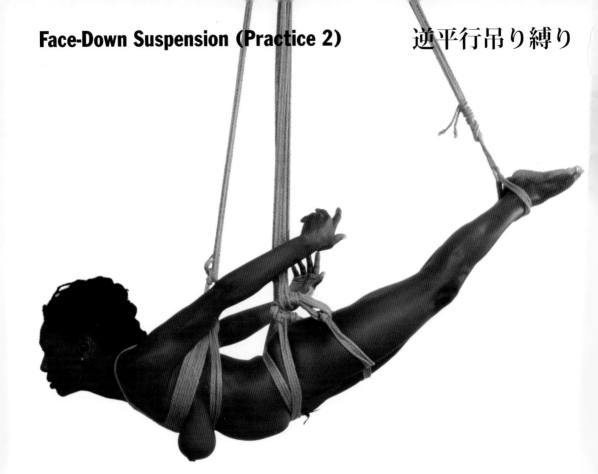

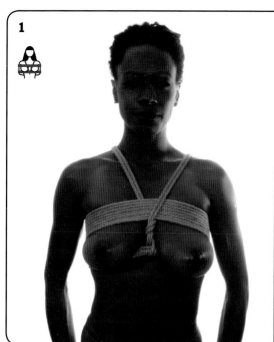

Chest Harness A or B, p. 50 or 52

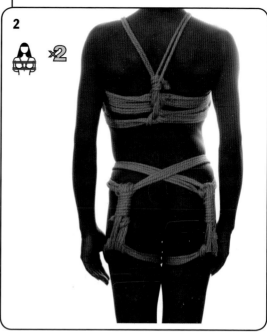

Gunslinger Suspension Harness, page 54

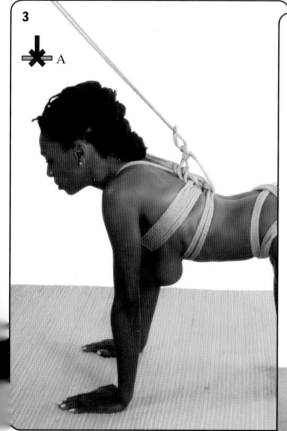

A

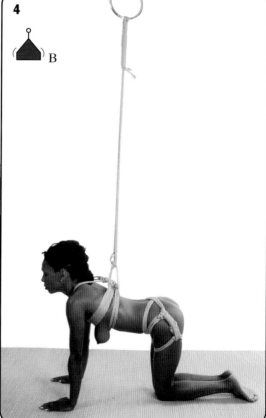

B

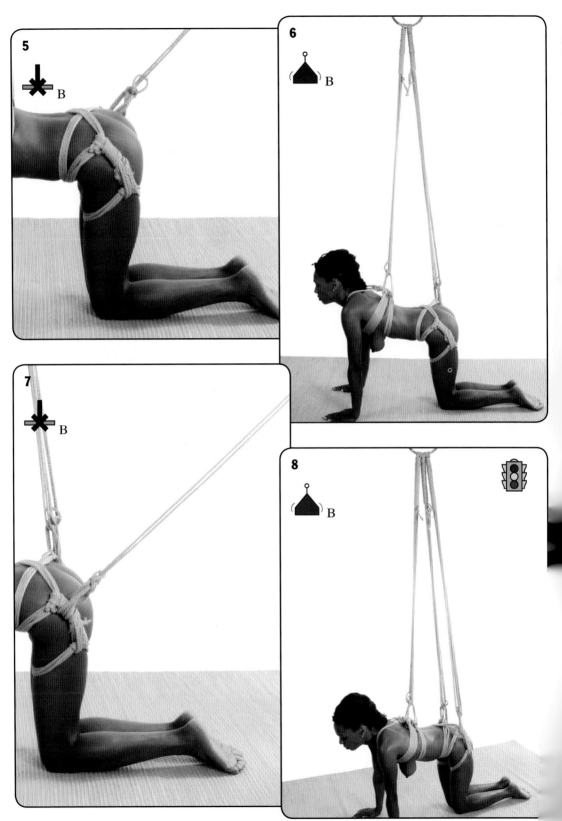

66

7

8 A

さらに

If her shoulders are above her hips, consider readjusting the suspension lines.

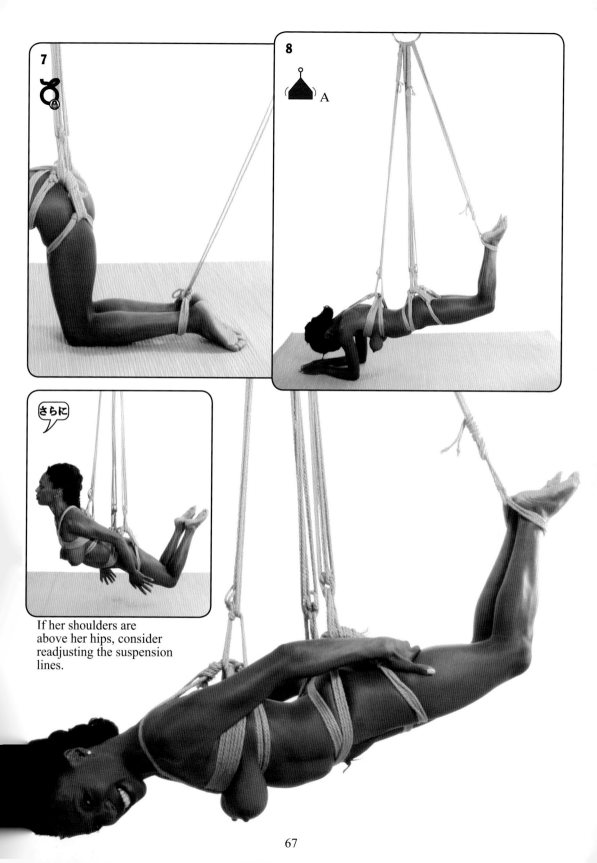

67

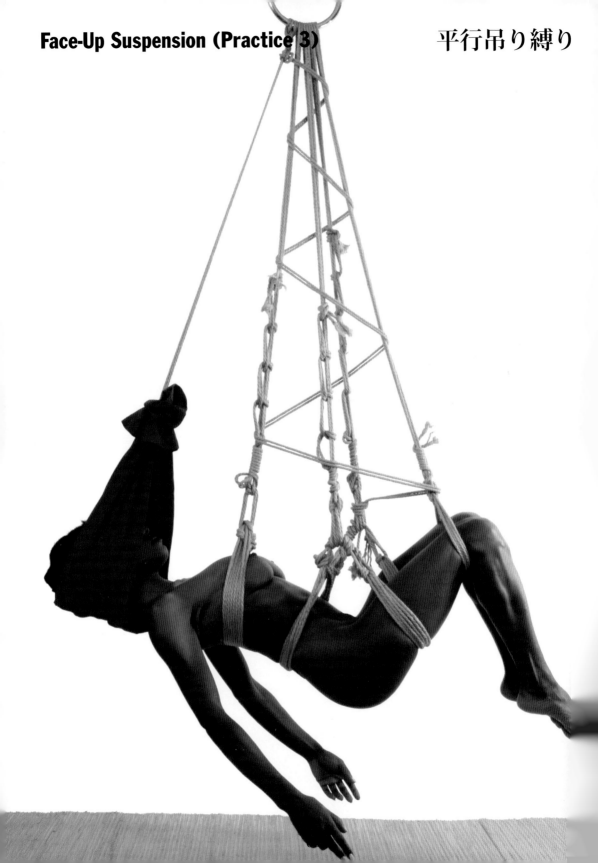

1

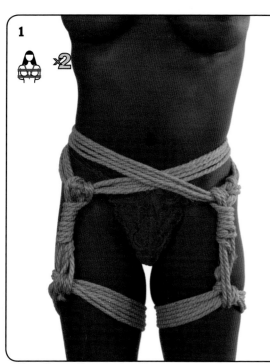

Gunslinger Suspension Harness, page 54

2

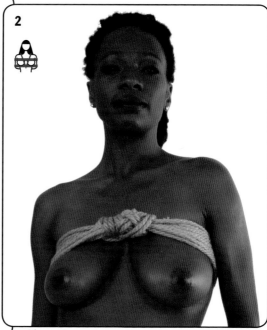

Chest Harness A or B, page 50 or 52

3

B

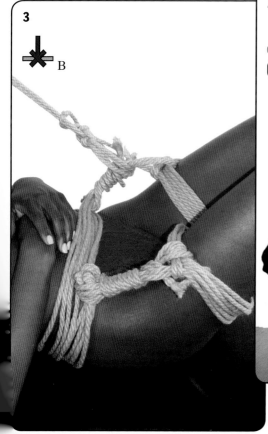

4

B

さらに

Any solid bench will do; directions for building *this* bench are in *The Better Built Bondage Book*.

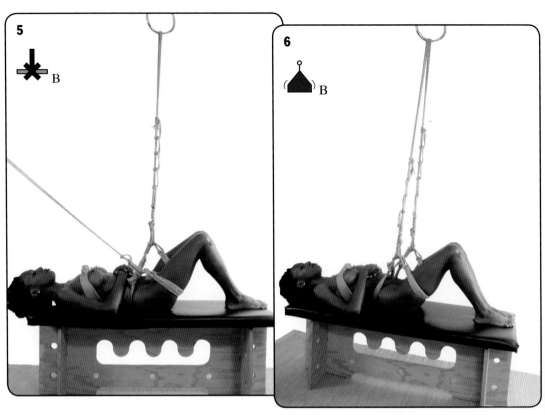

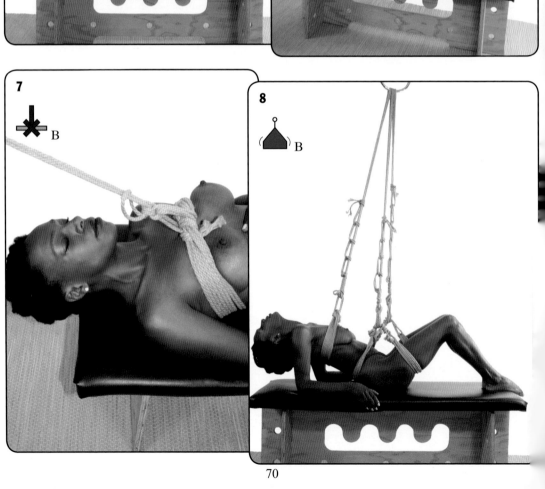

9

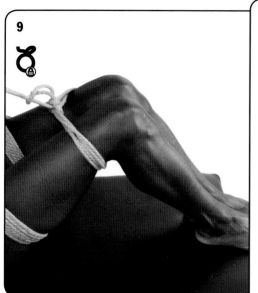

10

A

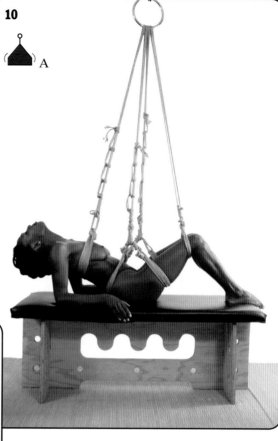

11

さらに

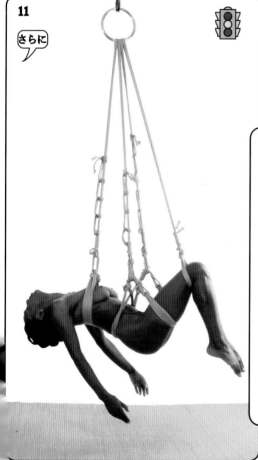

Gently remove the bench.

12

さらに

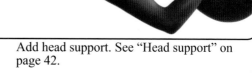

Add head support. See "Head support" on page 42.

M-Shaped Suspension
One-Leg Hanging Partial Suspension

M字開脚吊り縛り
片足上げ吊り縛り

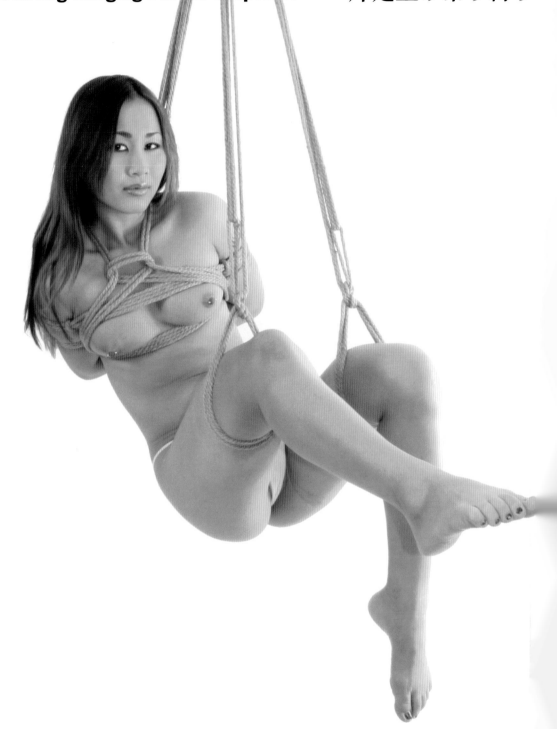

1

Box Tie

2

A

3

B

73

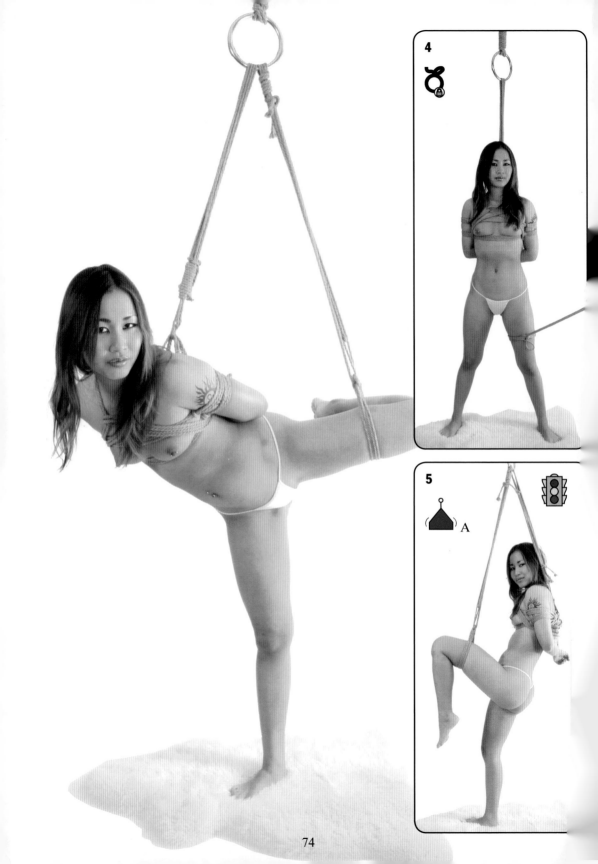

4

5

A

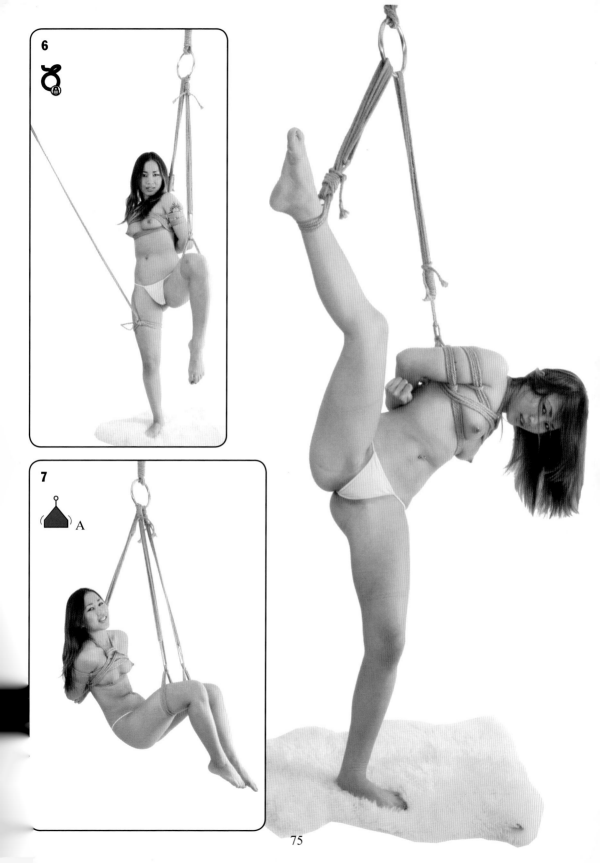

6

7

A

Limb Suspension
Ankle Suspension

狸吊り縛り
逆さ足首吊り縛り

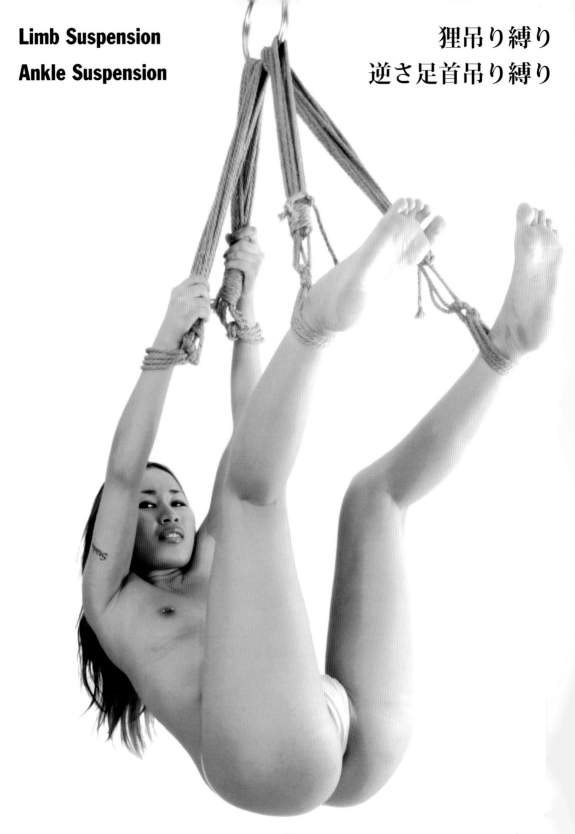

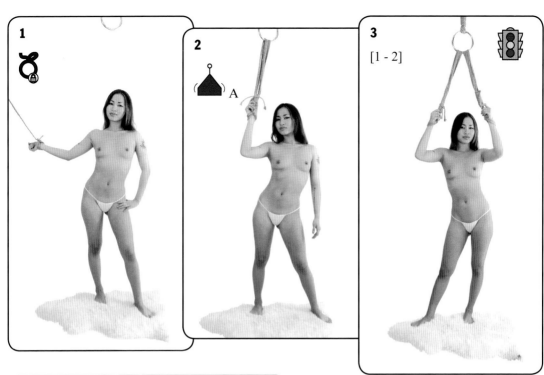

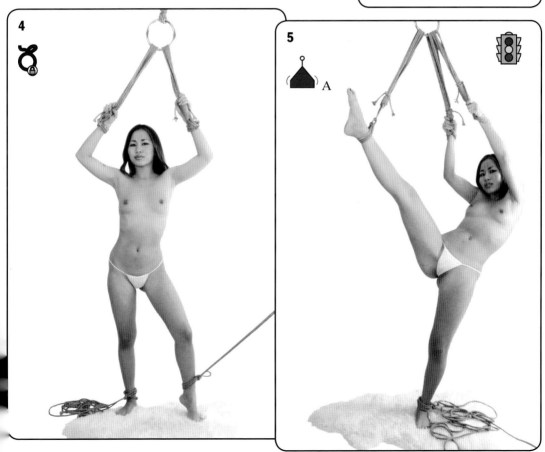

6

[4 - 5]

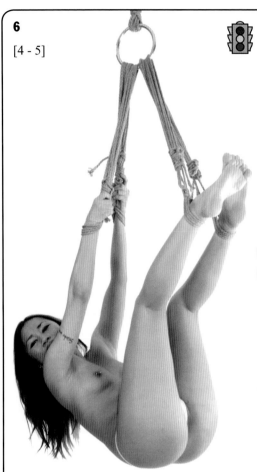

7 Optional

さらに

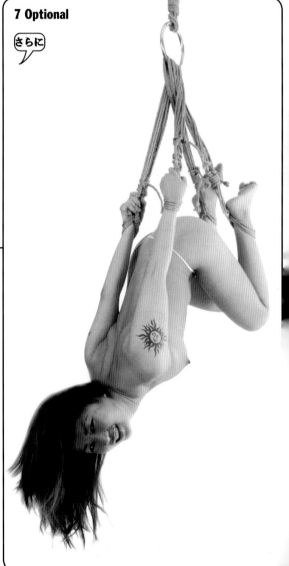

Optionally, help her
flip face down. Provide
physical support as
required.

8 Optional

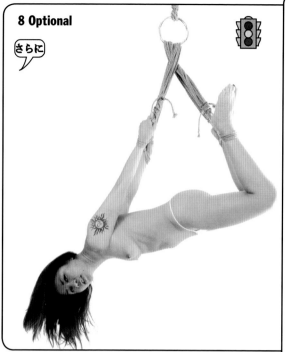

9

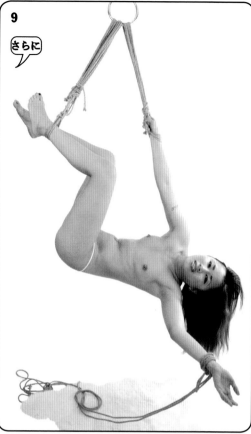

Help her flip back before continuing. Remove the two wrist suspension lines. Removing one ankle suspension can be very stressful on the last ankle so instead, support her, then remove the ankle lines.

10

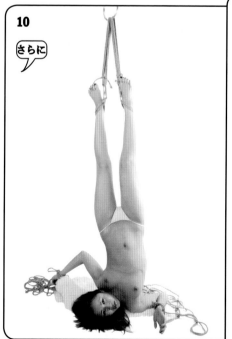

11

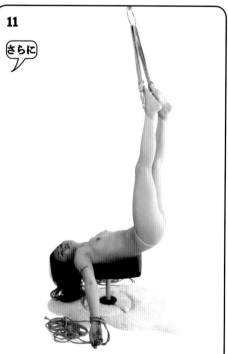

Hogtie Suspension

逆海老吊り縛り

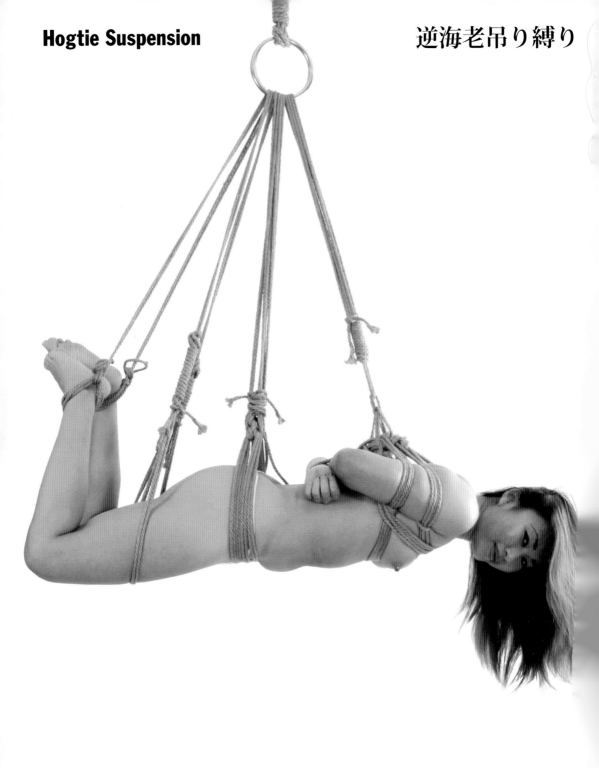

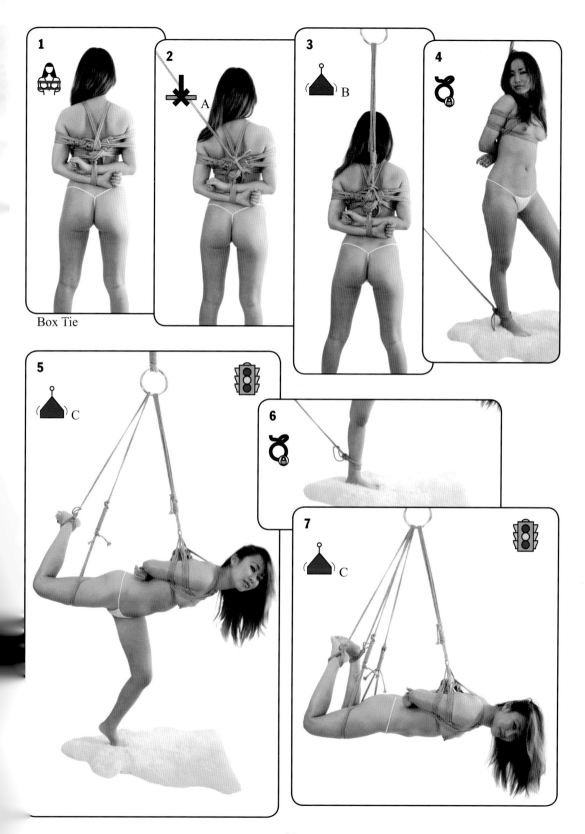

1

Box Tie

2

A

3

B

4

5

C

6

7

C

8

Torso Loop

9

B

10

B

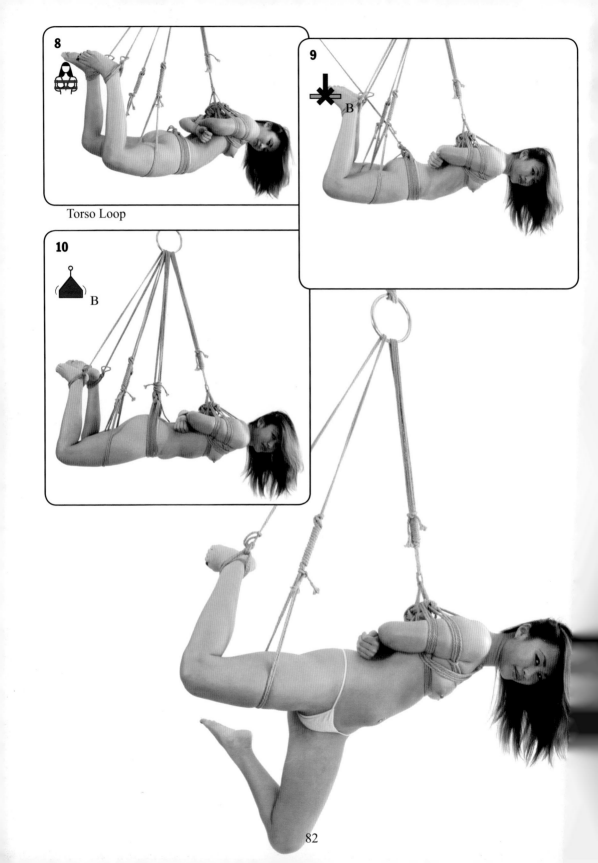

82

横吊り縛り

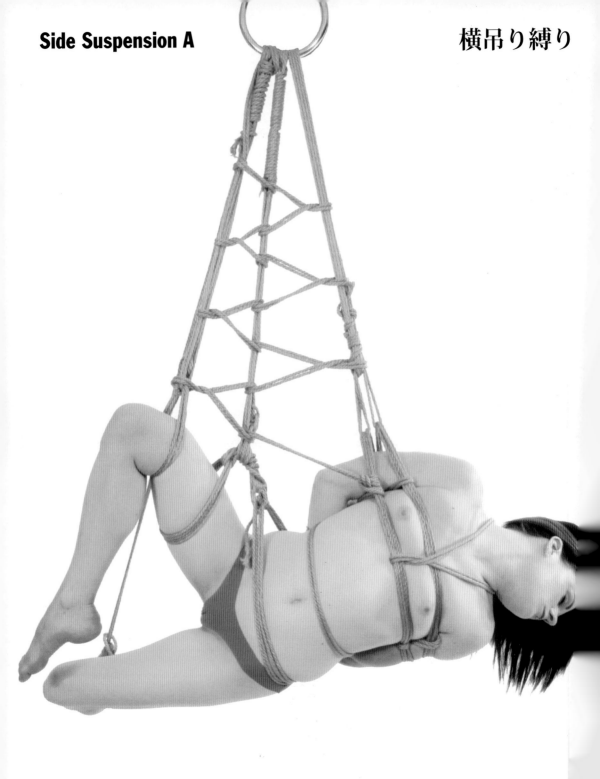

1

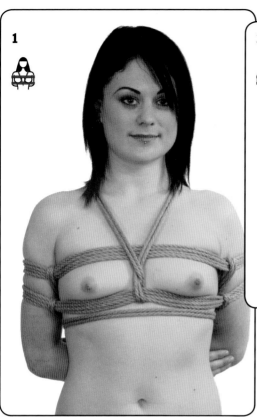

Box Tie

2

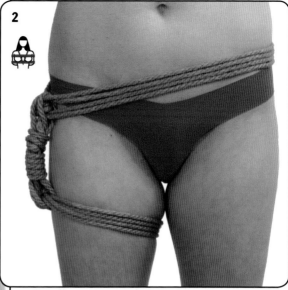

Gunslinger Suspension Harness, page 54

4

B

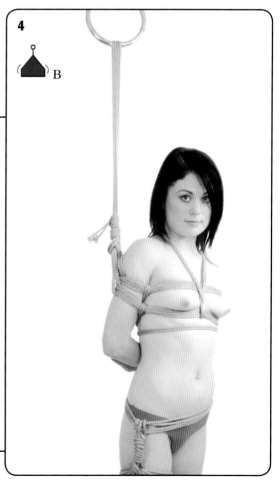

3

B

さらに

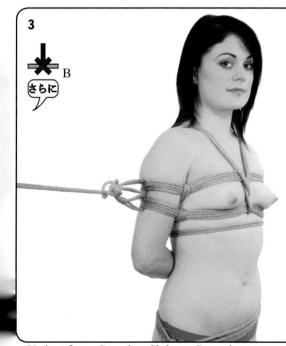

Variant from *Complete Shibari: Stars* shown;

85

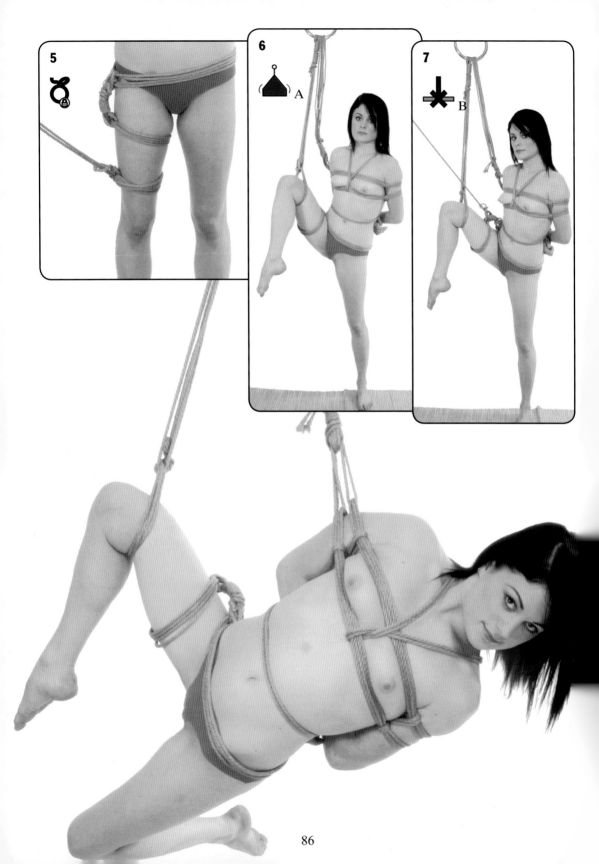

5

6 A

7 B

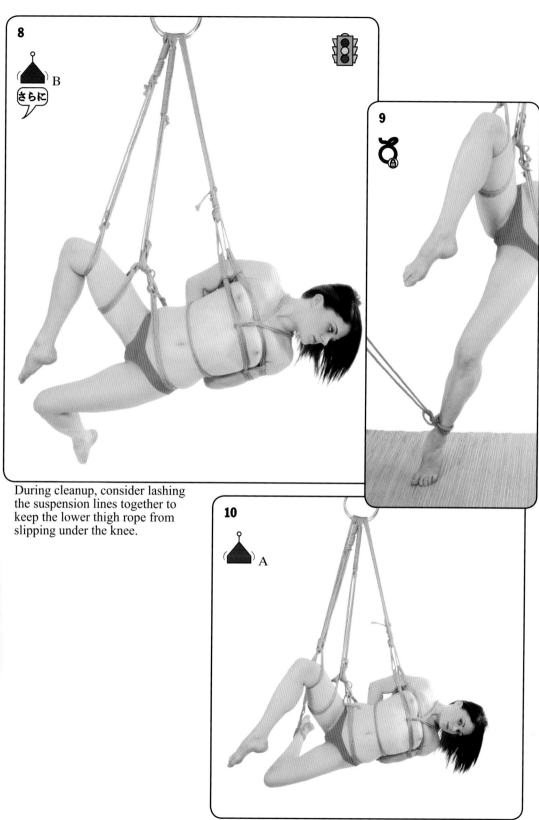

8

B

さらに

During cleanup, consider lashing the suspension lines together to keep the lower thigh rope from slipping under the knee.

9

10

A

87

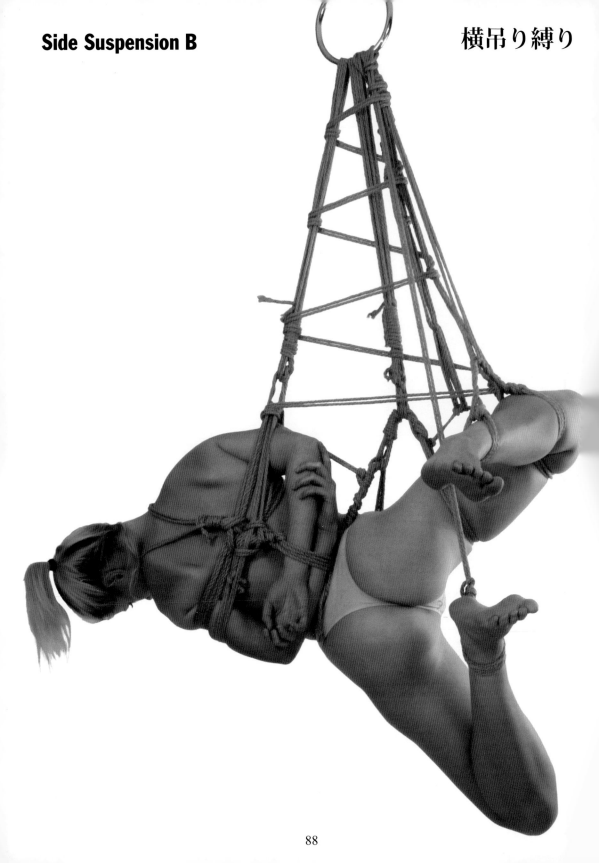

1

Box Tie

2

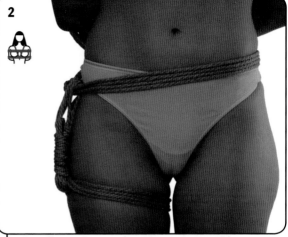

Gunslinger Suspension Harness, page 54

4

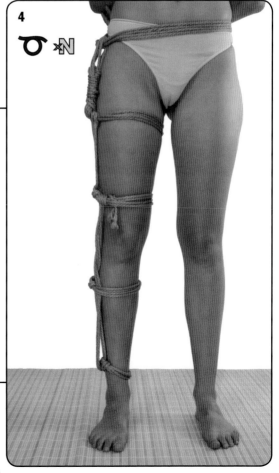

3

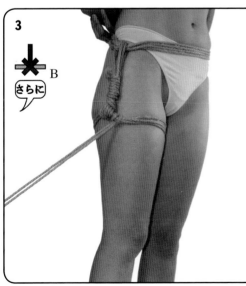

For speed, the Lark's Head is used here and in step 9. Although introducing single points of failure, the tie will be rigged such that a complete failure of this specific suspension line has little consequence (because the line supports only one leg).

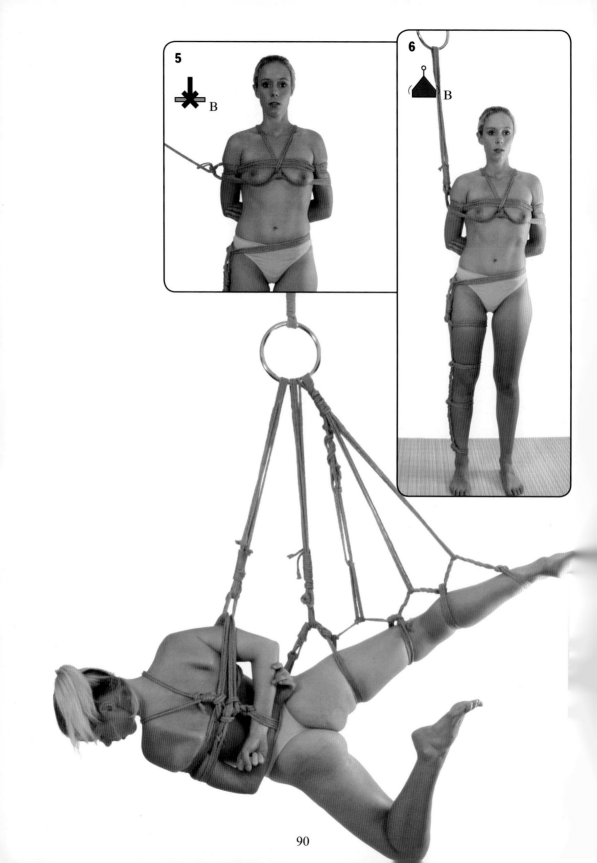

5

B

6

B

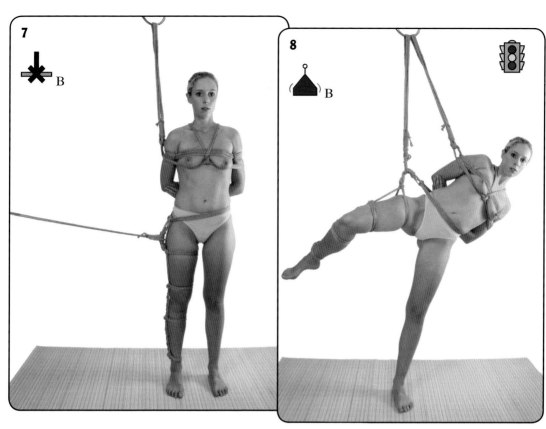

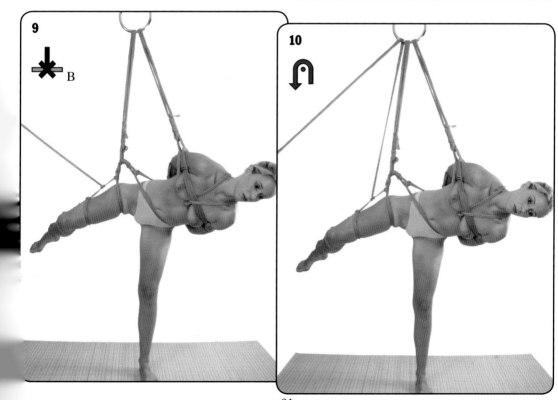

91

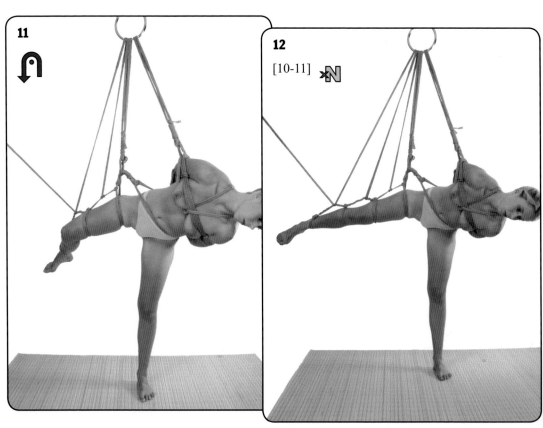

11

12 [10-11]

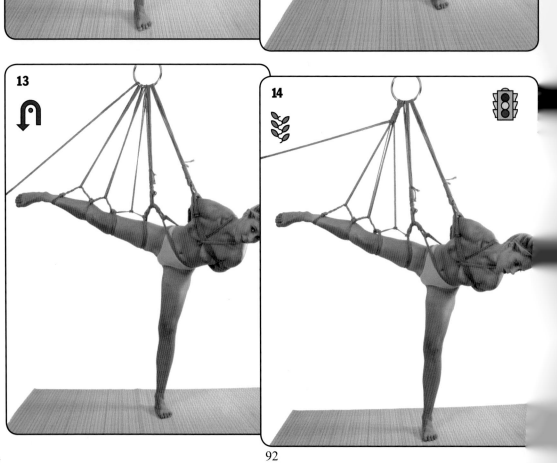

13

14

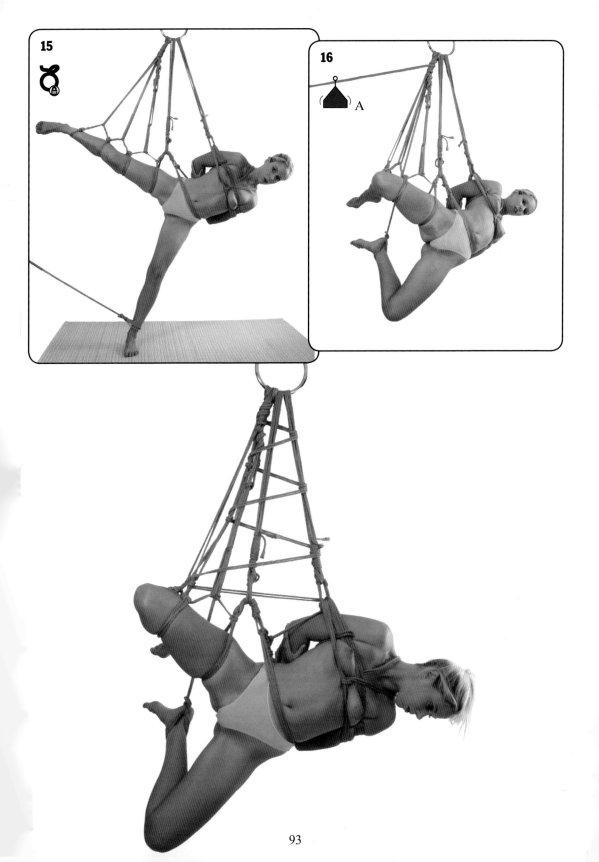

15

16

A

Inverted Suspension

片脚逆さ吊り縛り

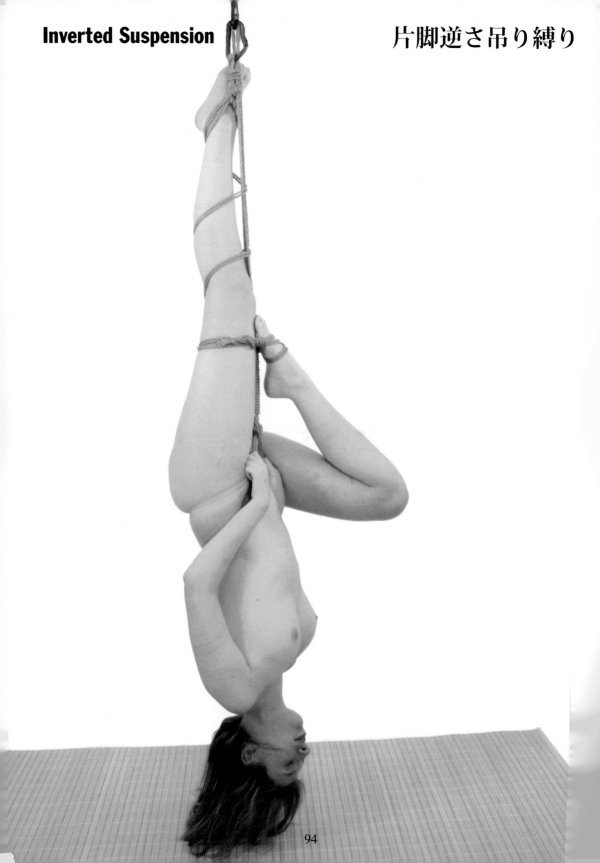